Contents

Acknowledgements

This book has grown out of my work, over the last five years, with Mediumwave, a community arts group based in Lambeth, in south London. I would like to thank Hannia Janiurek and Kevin Nessling, the other two members of the group, for their support and encouragement and their willingness to see the book as a part of our work.

The arguments in the book have their beginnings in two pamphlets written jointly by Dermott Killip and myself, while he was a member of Mediumwave. I am indebted to Dermott for allowing me to develop the arguments in these pamphlets, and for continuing to provide invaluable advice and assistance even when he disagreed with the direction in which the arguments were being developed. Without him this book would not have been written.

I would like to thank Peter Brinson, Phil Cope, Rod Henderson, Sheila Henderson, Andrew Howard, Karen Merkel, Dave Morley and Ken Worpole, who offered specific criticisms of previous drafts, and advice as to how they could be improved. Some of it I ignored. Most of it I didn't.

I would like to thank Sue Burd for her help, encouragement and tolerance. Without her this book would never have been finished.

Finally I am grateful to the Calouste Gulbenkian Foundation for providing a grant which enabled me to undertake the necessary research, and for doing so in a way which was in accordance with the aims of the project.

Introduction

This book is concerned with the growth of a community arts movement in Britain during the last fifteen years. Community arts began as one strand of activism, among many during the late 1960s, and community artists claimed to share the political, social and cultural goals of those other movements: the underground press, organised squatting, free festivals, the yippies and the Black Panthers. Yet I believe that community artists have, in the main, moved away from these goals, and are now further away from achieving them than ever. The community arts movement faces several major problems which it has consistently failed to confront. If it does not face these soon, it will become just one more worthy branch of whatever this government chooses to leave of the welfare state. Meals on wheels, homemade scones, inflatables and face painting: the kindly folk who do good without ever causing trouble.

Community arts is a general term for a group of cultural activities which the practitioners recognise as having common features but whose precise boundaries remain undrawn. The activities referred to usually include mural painting, community photography, printing, community festivals, newsletters, drama, video projects and the like. However, not all examples of the above would be recognised by all community artists as community arts. The community arts advisory panel of the Greater London Arts Association has produced a policy paper which contains a provisional definition of community arts, which it calls its 'terms of reference'. This will serve as a starting point to indicate the field with which this book will be concerned.

This paper says that 'the term *community arts* does not refer to any specific activity or group of activities; rather it defines an approach to creative activity, embracing many kinds of events and a wide range of media ... The approach used in community arts enjoins both artists and local people within their various communities to use appropriate art forms as a means of communication and expression, in a way that critically uses and develops traditional arts forms, adapting them to present day needs and developing new forms. Frequently the approach

involves people on a collective basis, encourages the use of a collective statement but does not neglect individual development or the need for individual expression . . . Community arts proposes the use of art to effect social change and affect social policies, and encompasses the expression of political action, effecting environmental change and developing the understanding and use of established systems of communication and change. It also uses art forms to enjoy and develop people's particular cultural heritages . . . Community arts activists operate in areas of deprivation, using the term "deprivation" to include financial, cultural, envronmental or educational deprivation.'

The first major problem which the community arts movement faces is that it has no clear understanding of its own history. It has neither documented its own history, nor drawn any conclusions from it. Community artists have therefore failed to develop a consistent set of definitions for their activities, with the result that the movement has staggered drunkenly from one direction to another. In effect, the policies of the funding agencies have determined who was, and who was not, perceived as community artists. Knowledge has not been passed on, and each crisis that community artists have faced has been faced as though for the first time. This is not to say that community artists have faced these crises badly. On the contrary, they usually acquitted themselves well, and often won real victories. What they were prevented from doing, however, was drawing on a knowledge of their own history in such a way as to predict crises, and thus circumvent them. They were reduced to reacting each time after the event.

The first section of this book is a historical view of the development of community arts. In this section I have deliberately opted for a tight focus which highlights some aspects of this history, and misses out other aspects altogether. It is not meant to be a comprehensive history, and it is certainly not an objective one. Instead it concentrates on a number of key moments which I believe served to determine subsequent events in ways which are central to my overall argument. For this reason I have greatly simplified the often exceedingly complex, and labyrinthine, chains of events which actually took place. I have similarly drawn distinctions between different strands of the movement which are much more schematic than they would be in a balanced history. In reality, people held complex and changing positions, and there were very few consistent villains. Nonetheless, the distinctions I have drawn represent the way that events were acted out as I perceived them. I believe, for example, that a liberal pragmatism

served, early on, to cripple the political development of the community arts movement, and to yoke it to those agencies who had shown interest in funding it.

This pragmatism led the movement to seek money whenever it could find it and to imagine that this money came without any strings attached. Naively, community artists imagined that they could take the money and run, although this turned out to be far from the case. This pragmatism is at the heart of the second problem which the movement faces. Entranced by the apparent short term gains, in terms of funding and recognition, which this pragmatism had brought, the community arts movement has refused to construct any theoretical framework for its work, and has ignored any attempts that have been made to do so. Instead it has relied on the kind of 'common sense' definitions which can be manipulated and twisted, with the result that community artists are increasingly told what to do, and how to do it, by people whose motivations often directly contradict the alleged aims of the community arts movement. We have become foot soldiers in our own movement, answerable to officers in funding agencies and local government recreation departments.

Without a theoretical framework, it is impossible to judge success or failure, and impossible to set goals. Instead everybody 'knows what they mean' although nobody has the vocabulary to express it, and being unable to express it they have no way of finding out if it does, in fact, make sense. In refusing to analyse our work, and place that analysis into a political context, the community arts movement has placed itself in a position of absurd, and unnecessary, weakness.

The second section of this book sketches out such a framework, and suggests a context within which the goals of community artists make an important kind of sense. This is not a theory *of* community arts, with rules about what we should and should not be doing. It is a map of the terrain within which community arts finds itself, with notes about those landmarks which seem, to me, important or relevant to our future development. In doing this, I propose a series of definitions for, among other things, *community* and *art*, which are attempts to indicate ways in which we might use the terms constructively. They are, at best, provisional definitions, and I am under no illusion that they are exhaustive or complete.

In this section I have described the network of social forces within which community arts takes place, and with which it interacts. I have tried to describe this network in such a way that its power is seen as considerable, but not total. This network, which includes the state and

what I shall refer to as the information industry, determines the way that we act, and the ways that we think, but it does not totally determine them. People are determined, but they also *determine* the institutions that they create. They are not robots, programmed to carry out particular tasks, but neither are they free to shake off their limitations and, in some voluntaristic manner, wipe the slate clean and start again. We operate within constraints, which we are free to change, but we are not free to abolish the principle of living within constraints.

Because the community arts movement has no coherent sense of its own history, and no political framework within which such a history could be located, it has been unable to construct any programme which might give effect to its aims. This is the third major problem it faces. I am not suggesting here that the activities of individual community artists, or community arts groups, have been aimless. Far from it. Much carefully constructed work has been executed by community artists, for clearly conceived purposes, with important and tangible results. This work has never been coordinated programmatically, however, as a part of a unified strategy. Local gains have remained local, and have thus been subjected to subsequent erosion through the constant pressures executed by the centralised state. Although individual groups may very well have programmes, the movement as a whole has never admitted to one, and has been very reluctant to admit the need, or the possibility, of one. Instead, it has concentrated on administrative and bureaucratic issues, or on issues of simple finance. It has preferred to beg for more money rather than to evolve a programme which might strengthen it beyond the need for begging.

The third section of this book suggests the basis for a programme, and the possibilities that such a programme would open up for our subsequent growth and development. This is not a detailed programme which I am attempting to foist on to other community artists. The construction of such a detailed plan of action must be a collective act by the movement, openly debated and agreed. Instead, I aim to show the limits and constraints within which I believe such a programme would have to operate, to point out clearly those attitudes and activities which would contradict our declared aims, and to indicate those areas in which we might usefully focus our attention. I am not concerned, for example, to explain how to take photographs, or how to produce posters 'correctly', but rather with establishing the limits within which these activities can take place, and within which these activities will be useful in adding to collective understanding.

This book is written from the point of view of a participant, and it expresses my opinions about my participation in the community arts

movement. It is not, as I have said, an objective view and nor does it set out to be. It is, perhaps, an idiosyncratic view, and it may well be that there are many people who think of themselves as community artists who recognise almost nothing of their work within these pages. If that is the case, then I think they should tell their story before it is too late. I am concerned here with the ideas and motivations of community artists, and with the working methods we have evolved to bring these ideas into practice. I am not interested, therefore, in describing the day to day activities of specific community arts groups, and I have no interest whatever in embarking upon some kind of unofficial assessment procedure, which tries to pass comparative judgements on the work of named groups.

This means that I am deliberately choosing to take some things for granted and to assume that they do not need spelling out. I am not prepared to say in this book that Printshop A is better than Printshop B, and I am therefore unwilling to provide specific examples, in every instance, of 'bad practice'. At the other extreme, I am taking for granted that the community arts movement is operating against a number of dominant assumptions and that, for this reason, its work often takes place in a hostile climate, and is rarely easy. I am not interested, within the context of the argument I am advancing here, in awarding campaign medals or brownie points. I recognise that many community artists campaign actively against the manifestations of racism and sexism, and on behalf of oppressed or disenfranchised groups, and I recognise that this work is difficult and sometimes dangerous. This is what we expect, and I don't feel the need to congratulate myself, or the people with whom I work, for struggling against these oppressions.

This book is written primarily for those working in community arts, for those who have regular contact with this work, and for those political activitists whose aims and objectives parallel those of the community arts movement. It is one more step in a debate which has been continuing for some time, and it arises out of the many conversations and debates in which I have participated. It represents, I hope, an exposition of a set of beliefs held by at least one tendency within that debate, and although I accept responsibility for this particular exposition, I do not claim authorship of the ideas which are described here.

The analysis within the book is materialist; that is, it is based on a sense of interaction. In the words of Raymond Williams, it is based on a sense of people 'working on physical things and the ways they do this, and the relations they enter into to do it, working also on "human nature" which they make in the process of making what they need to subsist'. It has been written from the starting point of my personal

experiences as a community artist, and from the experiences of those I know and trust within the movement, and filtered through a set of theoretical assumptions and beliefs which we have endeavoured to test in the course of our practice.

There are many assumptions made in the arguments here which remain incompletely demonstrated. Some of these are dealt with in considerably more detail than would be possible here in other books and articles, which I have used as source material, and these are discussed in the footnotes. Others need further research. I do not apologise for including them, where they seemed relevant, or necessary, to stimulate further discussion. I have endeavoured to write a book in which the argument is open, rather than closed, and which provides the subject matter for further debate, rather than a collection of prescribed solutions to be swallowed whole. My hope is that this book can contribute towards the construction of a language with which we can fluently, and powerfully, discuss the specific contributions which the community arts movement has made and might make in the future, to the struggle for a more equitable society. Above all, in this book, I have tried to describe accurately the shapes of the relevant citadels, and to indicate both the importance, and the real possibility, of taking them by storm.

Owen Kelly,
July 1984

Part One

A partial history of community arts

Chapter One

The age of Aquarius

The community arts movement began in the late 1960s. It had no definite starting point since from its beginnings it was a movement loosely based on the retrospective recognition of the similarities of aim and method in the work of its founders. There was no manifesto, no official proclamation and no conscious attempt to establish an exclusive membership. Instead there was a fluctuating group of (mainly) young artists who were working in ways which were, at that time, unorthodox. Having recognised common threads in each others' work, they began to work more closely together, and to meet and discuss.

The work that they were doing was one part of the outpouring of apparently radical cultural activity that occurred from about 1967 onwards, when for a short time political activity, popular music, recreational drug-taking and new methods of contraception coalesced into a keenly felt desire for world peace and self-determination. This outpouring took many forms, from free festivals and re-emergence of the Fifties' best poets in kaftans, to the flowering of the underground press. It was one of the cultural aspects of a sustained economic boom which people had come to believe was permanent. Class conflicts, it was believed, had been superceded and a new classless politics was being instituted which would aim at giving power to 'the people'. Community arts was one of the ways in which these beliefs were made practical, and it was concerned with taking art 'into the streets' and 'giving it back to the people'.

Jim Haynes opened the Arts Lab in Drury Lane, in the centre of London, in July 1967. Shortly after that UFO opened at the Round House in Chalk Farm, and the Middle Earth opened in Covent Garden. By the end of 1968 there were arts labs open in Brighton, Birmingham, Liverpool, Cambridge and Halifax on a regular basis, and similar, though less organised, activities in most other major towns and cities. These were all concerned with trying to break down the restrictions deemed to be inherent in 'straight' social codes and structures: in the art world, the education system, the communications industry and the nuclear family. Marshall McLuhan had uncovered what was allegedly a Balinese folk saying

and elevated it into a temporary cosmic truth: 'We have no art, we do everything well'. This became one of the guiding notions of the nascent community arts movement, along with the idea that 'everybody can do everything', which was borrowed with a carefree eclecticism from 'philosophers' as various as Timothy Leary, Wilhelm Reich and Alan Watts.[1]

It was not long before the people organising this growing list of activities, centred around but not exclusive to the Arts Labs, realised that there was money to be had for cultural activities from the Arts Council of Great Britain.[2] They began applying for grants. The Arts Council felt obliged to respond in no small part because it could not afford to be seen to be obstructing the future. The economic boom through which Britain was passing was believed by many not just to be permanent, but to be the harbinger of a new age of leisure: the age of Aquarius which would result, among many other things, in 'the greening of America'. The media were full of people like Charles Reich proclaiming that the good times were outside waiting to come in, and all we had to do was loosen up for the party. In this climate the worst crime a liberal could be caught committing was siding with yesterday's men, and so in 1969 the Arts Council formed a 'New Activities Committee' to advise it on these applications.

At the same time as the Arts Labs were flourishing there were a number of parallel initiatives being taken by formally-trained artists, who had themselves become disillusioned with the limitations of the traditional fine art gallery system. This they saw as placing severe restrictions on the kinds of work they could do and the kinds of audiences they could hope to address. Some artists began to take their work out of the galleries to places where they imagined 'the people' naturally gathered, in the hope that it would then receive attention. *Pavilions in the Parks*, for example, was formed in 1967 by a group of visual artists with the aim of designing a set of lightweight, portable structures which 'could house a wide variety of the arts in parks and open spaces where people naturally take their leisure'. During the four years in which these schemes operated, work was shown in open spaces in Chelsea, Croydon, Greenwich, Swansea, Cardiff and Camden.

Other fine artists were concerned to develop work which was specifically designed to be located in public spaces, and which would challenge the expectations of those who saw it there. Robert Smithson and Joseph Beuys began to do this within the context of an international avant-garde; Smithson, for example, developing *land art* in which he produced enormous patterns in the desert soil and a huge spiral jetty in the Great Salt Lake in Utah. Stuart Brisley produced similarly public work in Britain, and was instrumental in

the development of *performance art* through his staging of public
events in which he deliberately pushed himself to the edge of his
physical limitations. Cornelius Cardew evolved the Scratch
Orchestra at this time, which gave performances with whoever and
whatever was to hand, and in 1971 David Hockney was appointed
town artist at Glenrothes in Scotland, with the task of injecting
beauty into the architecture and the environment of which it
stood.[3]

During this period there was an explosion of innovative, locally-
based political campaigning. Street politics and community activism
grew as a part of the hippy dream of an alternative society, but
slowly moved away from the starting points of free services and
advice about drugs to encompass a wide range of neighbourhood
issues, such as housing and claimants' rights. This was the period in
which Release and Bit were begun and the first claimants' unions
were founded. Community activists soon discovered the extent to
which their campaigns could be made more effective by the injection
of creative, artistic elements. Posters and exhibitions were valuable
tools for getting people to meetings, and videotapes were useful to
trigger discussion once people had arrived. These activities rapidly
became an integral part of community-based campaigns, and groups
such as West London Media Workshop began to form[4]. They took
up the local interest in video and photography and concentrated on
developing it and expanding its possibilities. They realised that the
equipment and skills that local people had acquired did not need to
be limited to serving campaigns as they arose, but could be used to
create projects of their own devising which might themselves lead to
the creation of campaigns.

Community arts was woven, then, from three separate strands.
Firstly there was the passionate interest in creating new and liberatory
forms of expression, which the Arts Labs both served and fuelled.
Secondly there was the movement by groups of fine artists out of the
galleries and into the streets. Thirdly there was the emergence of a new
kind of political activist who believed that creativity was an essential
tool in any kind of radical struggle. With the advent of groups such as
InterAction, Welfare State and Action Space (whose concerns were
as much to do with the alternative society as they were to do with art)
these strands were woven into a distinctive pattern of activities.

This process was by no means unique, and was acted out as a pale
example of an international upsurge of radical activity. The opposition
by young Americans to the Vietnam war had acted as a spur to young
people in France, Germany, Italy and England. In America both the
nascent women's movement and the Black Panthers were preaching
messages of liberation and the need to 'seize the time' and put an end

to oppression. The Black Panthers, in particular, had a highly developed cultural programme, and a revolutionary philosophy which emphasised the links between power, economics and culture. All of this provided the background before which the community arts movement was born in Britain.

In 1971, the 'New Activities Committee' of the Arts Council of Great Britain was wound up after publishing its final report, and was replaced by an even newer 'Experimental Projects Committee'. The following year this committee commissioned Rufus Harris to produce a report, *Community Arts in Great Britain*, in the course of which he organised a two day seminar at the Institute of Contemporary Arts in London. This was, in effect, the first national gathering of those people who had begun calling themselves community artists, and it was from this meeting that the Association of Community Artists began.

The founding members of the ACA were Bruce Birchall, Martin Goodrich and Maggie Pinhorn, and from the outset they were determined to be pragmatic and practical; they saw themselves as 'a hardcore group who were interested in organising and presenting a united front'.[5] Their concerns were therefore all externally directed. They were interested in the possibilities of funding; in finding out what money was available and how they could best lobby to make more available. Over the next seven years they, and the association they founded, were extraordinary successful at this. The ACA became *the* body which the grant-giving agencies recognised as speaking for community artists. It grew to have an active membership in all the regions of England coordinated by a national steering committee, and its members developed the capacity to organise conferences at which information could be shared and funding issues discussed.

It was, however, a very *Aquarian* organisation; pushy and powerful when dealing with simple practical matters, but eclectic to the point of sloppiness when it came to questions of theory. The ACA had been conceived, by its founding members, as a campaigning group; and that, they had decided, meant that they needed as many members as possible, in order to appear a credible opposition. This was taken to mean that anything which could be interpreted as in-fighting, or which could conceivably cause division, was to be avoided. Any idea of a manifesto was, therefore, explicitly rejected in favour of a deliberately general set of objectives which used terms (not the least of which were *community* and *art*) which were never defined, or even debated. The criteria for membership were negative rather than positive. It was what you were against, what you *weren't* doing, that was deemed important. What you *were* doing was reduced to a topic for discussion in the bar after the meetings. It was much easier to get everyone to

unite in opposition to the proportion of the Arts Council's budget that went on opera than to get people to agree on a set of collective goals.

There were two separate, but equally real, reasons why this was accepted, over and above any cynical belief that it was the easiest way to get at the money. The first was that, in practice, the distinction between what the ACA's initial members opposed and what they actually did was blurred. Most of them shared similar ambitions, attitudes and lifestyles, and most of them were reacting in broadly similar ways to approximately the same forces. More often than not they 'knew what the other meant', for they shared assumptions rooted in class, educational background and 'alternative' lifestyles. It was not until later, when the number of community artists had grown, and the variety of work being done and the levels of skill with which it was being approached had increased dramatically, that this distinction became important. It was later, when community artists could no longer be certain that they shared each other's motivations and understandings, that the failure to reach any agreed definitions, and the consequent inability to affirm anything but the vaguest of aims, became a major stumbling block to the movement's growth.

Secondly, there was the important historical fact that at the point when the ACA was being established most community artists were at a tentative and exploratory stage with regard to their practice. They knew, in general terms, what they were trying to do, but they had as yet few clear ideas as to *how* to do it. This meant that people were often reticent to talk about what they actually *did*, since the difference between people's declared aims and what they were actually able to achieve in an untried area with little or no money was often laughably (but unavoidably) large. It was much easier, and safer, to talk about what the work was opposing, and about the potential that it had.

This, indeed, is how the rapidly-established ACA began to sell itself to the Arts Council of Great Britain: as a repository of enormous creative and social potential which could only be brought into actuality by the granting of funding and resources. When, in 1974, the Arts Council set up a working party, under the chair of Professor Harold Baldry, to examine community arts, the ACA responded by submitting a *Directory of Community Artists*, which listed 149 groups and an additional 14 individuals. These were not necessarily groups who were being funded lavishly (or at all); nor were they groups with lengthy track records. Rather they were groups with 'potential', and the ACA's concern was to demonstrate the size and scope of that potential, in the belief that the Arts Council would then give them the funding they needed to do the work they wished to do.

In the event this ploy was used against them, and what they got was rather different from what they anticipated. They got the money they

wanted, but it came in forms which directed the community arts movement away from the areas of danger in which its founders had been dabbling, and towards altogether safer pastures. In this, too, it was perhaps typical of those movements which began during the shortlived age of Aquarius, and subsequently disappeared, or diluted themselves, through the naivety or the short attention-span of their membership. Yet even if this is so, it does not invalidate the original questions which the community arts movement raised; questions about the role of art in society, and the relationship between cultural and political struggle. Nor does the subsequent collapse of the community arts movement into the waiting arms of the state make these questions any less important.

Chapter Two

The Baldry Report

At the end of 1973 the Arts Council's 'New Activities Committee' decided that the projects that it was funding 'seemed mainly to come under two categories, which could be described as *performance art* and *community arts*'. Performance art was decreed the responsibility of the Arts Panel, for performance artists, although working in a different medium (or in no medium at all), shared the goals and ambitions of fine artists, and spoke the same language. Community arts was deemed somewhat more problematical, and a working party was established to determine what it was, and whether or not the Arts Council should be funding it. *The Report of the Community Arts Working Party*, under the chair of Professor Harold Baldry, was published in June 1974, and it concluded that a community arts panel should be established, for an initial period of two years, and that an additional officer should be appointed 'to deal with community arts matters'.

These recommendations were carried out and the panel was given a budget of £176,000 in its first year, which it awarded to 57 projects; and £350,000 in its second year, which was distributed among 75 projects. An Evaluation Working Party was then established which pronounced the 'experiment' a success, and recommended its continuation on a more permanent basis. At the same time, worried by the political activities of some community arts groups, it pointedly reminded the Council that 'there is clearly no justification for funding any activity which is not art based'. The Community Arts sub-committee duly carried on until 1979 when, as part of a larger restructuring programme, the responsibility for funding community arts was 'devolved' to the Regional Arts Associations.[7]

Although the Evaluation Working Party introduced several notes of cautious disquiet about the political aspects of some community arts practices it neither added to, nor amended, any of the arguments about community arts advanced in the Baldry Report, which remained the foundation of the Arts Council's policy towards community arts. In many ways this report *determined* the subsequent growth of community arts, and it will pay us to examine its arguments in some considerable detail.

The report begins by stating that, although it was offered many

definitions of community arts, it 'found none of them completely satisfactory', and goes on to suggest that 'the search for definition is probably futile'. Nonetheless, the report says, it is 'possible to pick out certain features which add up to a distinctive picture'. The next few sections of the report describe the various distinguishing marks by which the community artist can be recognised, and which 'add up to a distinctive picture'.

'The key element in this picture is an individual or group of individuals, perhaps best describable by the word commonly used for them in France, *animateurs*. They are likely to form themselves into an organisation of variable size and complexity, with a name and sometimes even with a constitution. They are also likely to have a place which they use as a base for their activities, and which they may call an *arts centre* or *resource centre*. The importance of this place for their work and the extent to which their activities happen there is variable . . . What matters most is not an organisational form, nor bricks and mortar, but the commitment and dedication of the individuals involved.

Community artists are distinguishable not by the techniques they use, although some are specially suited to their purposes, but by their attitude towards the place of their activities in the life of society.

Their primary concern is their impact on a community and their relationship with it: by assisting those with whom they make contact to become more aware of their situation and of their own creative powers, and by providing them with the facilities they need to make use of their abilities, they hope to widen and deepen the sensibilities of the community in which they work and so enrich its existence. To a varying degree they see this as a means of change, whether psychological, social or political, within the community. They seek to bring about this increased awareness and creativity by involving the community in the activities they promote; and because children are most easily involved they often work to a large extent with children and hope through this to involve the adults as well. They therefore differ from practisers of the more established arts in that they are chiefly concerned with a process rather than with a finished product: a many-sided process including craft, sport etc in which the 'artistic' element is variable and often not clearly distinguishable from the rest.

The community with which they are concerned is usually, but not necessarily, the population of a limited geographical area or *neighbourhood*. Some of their activities, however, may be extended further afield . . .'

These are the *only* descriptions in the entire report of what community

arts are, and what community artists do, and they contain a number of striking features, which served to direct and constrain the subsequent growth of the community arts movement. Firstly, those writing the report argue (as did the founding members of the ACA) that it is unprofitable, if not actually impossible, to define what community arts is; and that if it must be done then it is best done tangentially by a process of hinting. Secondly, they refuse to even hint at what it is that community artists actually *do*. There is almost no mention in the report at all of the kinds of actual activities which community artists might have been found doing. Instead, all we are told is that they do 'it' with children, that they are not especially concerned with what finally gets produced, and that 'it' usually happens within a limited geographical area. Even this meagre information is hedged and fenced with adjectival phrases like 'to a large extent' and 'usually but not necessarily', whose effect is to cast into doubt the applicability of what little we have been told. Community artists, it is said, see this work 'to a varying degree . . . as a means of change'.

Even at this stage in the development of community arts it would have been possible to be much more specific about what 'it' was, and what sort of things 'it' did. Among the first groups funded, and about whom the working party had some knowledge, were Bath Arts Workshop, Fine Heart Squad, Free Form, Harry's Big Balloonz, Magic Lantern, Puppet Tree, Steel 'n' Skin, and the West Indian Carnival Committee. The range of activities undertaken by these groups included organising large outdoor festivals, painting murals, running creative games sessions with puppetry, inflatables, traditional English folk dance and African dance and drumming.

Despite the apparent range of their activities they all shared certain similarities. They were all concerned with processes of *collective creativity* which stood in stark contrast to the model of 'individual creativity' which had dominated European high art for at least two centuries, and which has posited the artist as a man removed from, and above, the ordinary human being. 'Great artists have no country', said Alfred de Musset, while Coleridge believed that 'the souls of five hundred Sir Isaac Newtons would go to the making up of a Shakespeare or a Milton'. While the members of the Arts Council at the time of the Baldry Report would doubtless have regarded these particular statements as somewhat over the top, the tradition from which they came was still, somewhat modified perhaps, the dominant tradition. It was after all only 15 years before the Baldry report was published that a previous Secretary General of the Arts Council had seen his job as nurturing 'few but roses'. Not only had this phrase become the title of an Arts Council annual report, it had also become a catch-phrase used by those who believed that the role of the Arts

Council was to fund a few exemplary 'centres of excellence' and that anything else was a dangerous dilution of this vital function. It was in opposition to this that comunity artists at this period adopted the slogan 'let a million flowers bloom'.

The Baldry Report fails entirely to grapple with the difference between a belief in collective creativity and a belief that creativity is essentially and necessarily individual. Instead it argues only that 'community artists are distinguishable not by the techniques they use, but by their attitude towards the place of their activities in the life of their society'. Not only is this weak and evasive argument, which seeks to hide a potentially explosive issue, but it is phrased in such a way that obscures a series of important issues.

The Baldry Report uses the word 'technique' as a synonym for 'art form', which is not only idiosyncratic but serves to mask the issues surrounding the ways in which those art forms were being used. It is not *what* was being done that is interesting but *how* it was being done. In fact, it was precisely in the area of technique (in the usual sense) that community artists were breaking new ground. They were devising methods of working which were based around groups, and they were trying to develop ways in which the groups could draw upon the strengths rather than the weaknesses of the people involved, and in which every member could make a contribution without feeling debarred by the stronger or more confident members. They were also wrestling with some success with the problem of the artist's contribution to the group; of how the artist could make a contribution without their skills and experience coming to dominate the group's work.

All of this the working party noted obliquely, if at all. While community artists were struggling to develop techniques, skills and tools which would enable them to place their 'activities in the life of their society' in such a way as to be an active force for change, the working party, in its report, found that it could only describe this struggle as an interesting 'attitude'. In doing this the working party neither approved nor disapproved of community arts as it then existed; rather it missed the point and approved instead of something so general and so woolly that it could scarcely be described. But the Baldry Report was not produced in this way through stupidity or accident. Indeed the people involved were well aware of the report's lack of specificity, and had carefully contrived it with a particular purpose in mind. That purpose was to assist community artists to obtain the funding they claimed to need in the face of hostile criticism. This was a benevolent purpose, and in the short term and in the way in which it cleverly and exactly fulfilled that purpose, the report was a success. In the longer term, however, the vagueness of all that the

report said would prove profoundly detrimental to the development of the community arts movement.

The report was constructed by a group of people who were, broadly speaking, sympathetic to what they found community artists doing, as they travelled around the country meeting them, and as they read through the various reports they were sent. They felt themselves, however, to be unrepresentative of the feelings of the Council of the Arts Council and, rightly or wrongly, they felt that it would take great diplomatic and political skill to persuade the Council that what they had seen was worthy of funding, given the range of other activities which the Arts Council was funding, and the views of those sitting on it. They therefore constructed the report strategically, taking care to provide as little ammunition as possible for those they saw as their opponents. From this perspective it mattered little what the report said about the activities of community artists (in fact, the less it said the better), only that it provided a mechanism by which a group of people whose aims and tenacity the working party had come to admire could receive the funding they claimed to need to carry on and develop their work. The report was constructed as an answer to the immediate problem that was encountered in the internal politics of the Arts Council, and in this respect it was doubtless typical of many reports written in many quangos and government departments.

The main thrust of the report in fact comes in its later sections, when having described community arts in terms so broad as to make disagreement difficult, the working party outlines the reasons why they believe that the Arts Council should provide funding. They do this by defining an approach for themselves which, in strategic terms, renders opposition almost impossible.

'To the familiar question "Is it art?" the Working Party could find no simple answer. The question itself takes for granted concepts not applicable in the sphere with which we were dealing. Each of its three apparently simple words implies an assumption – that the matter under discussion is an existing object rather than a developing potentiality, a thing rather than a process, and that "art" is a permanent definable reality rather than a term whose meaning has varied in the past and will vary in the future. The Working Party thought it wiser to approach the problem by considering how community arts, as described in the previous section, is related to the aims for which the Council was established, as stated in clause 3 of its charter'.[8]

Having thus ruled any of the obvious objections out of order, the working party proceeds to dissect clause 3 of the Arts Council's

charter phrase by phrase, and then to demonstrate how each phrase can be understood in a way which is favourable to the funding of community arts. From there they move straightaway into a discussion of the ways in which the Council could fund community arts, and the administrative machinery that would need to be established for it to do so.

There were no sustained objections to the report's recommendations, and the Council accepted them. Community arts became officially recognised, and sizeable sums of money resulted from this recognition, almost immediately. However those community artists (and there were many) who believed that we could take the money and run were to be proved wrong. The Baldry Report had enshrined the vagueness that had been at the heart of the ACA's campaigning strategy, and had more or less sanctified it as a modernised creative mystery. This was rapidly exploited by officers and members of the Arts Council, and later by people within the Regional Arts Associations, for ends altogether different from those envisaged by the members of the ACA who believed they had pulled off some sort of cultural smash and grab.

Chapter Three

Redefinition

The community arts movement had hardly entered the halls of 105 Piccadilly before moves were made to trim its sails, and to change its course. In *The Arts In Hard Times*, the Arts Council of Great Britain's annual report for 1975/76, the then chairman Lord Gibson decried the notion of *cultural democracy* which was beginning to be used by many community artists to describe their objectives. He characterised this as a term 'which rejects discrimination between good and bad and cherishes the romantic notion that there is a "cultural dynamism" in the people which will emerge if only they can be liberated from the cultural values hitherto accepted by an elite, and which one European "cultural expert" has recently called "the cultural colonialism of the middle classes" . . . This demagogic doctrine insults the very people it is supposed to help. On the one hand, what is undoubtedly true is that many people who have had no chance to enjoy the arts can be helped to approach them by being encouraged to participate in creative activity rather than merely to experience it passively. It is this feature of community arts which is of particular interest to the Council.'

At this point the strategy of deliberate vagueness which had been pursued in different ways by both the ACA and Professor Baldry's working party became a two-edged sword. Within the Arts Council the goals of the community arts movement began to be subtly shifted, as officers with empires of their own to administer began to fill in the spaces with designs of their own, aimed at herding community artists into reservations in the barren areas of the established terrain.

The intentions of those who had started the community arts movement had been to enable working people to be creative in ways that would make their creativity socially effective. They had never produced any rigorous analysis of these aims, nor developed any clear programme for achieving them, but they had 'known what they meant'. They had wished to work in this way for two reasons. Firstly, they believed that people's new-found effectiveness in the area of creativity would raise their morale and lead them to seek to empower themselves in other areas of their lives; and secondly they believed as a matter of principle that it was everybody's right to participate in the

shaping of the world in which they lived. As Ken Lynam, a founder member of West London Media Workshop, said: 'Really what should happen is that people should be able to control the means of communication themselves . . . community controlled communications networks, that's the long term objective'.[9] In contradiction to this, the aims of community arts as espoused by Lord Gibson are to enable people to be creative solely so that they can learn about art from the inside, find out how much they have been missing, pull themselves together and start attending galleries, theatres and concert halls.

This *had* undoubtedly been, from the outset, one of the many possible side effects of community arts practices, and some people had probably travelled along just the path that Gibson envisaged. This educative role had always been a side effect, however, and had never been seen by community artists as the real reason for their activities. Now a spotlight was being turned on this side effect which was being hailed as the star of the show. It was pushed into the centre of the stage, while subsidised stage hands tried to bundle the original purposes into the wings. The job of the stage hands, however, was not entirely possible. Although Gibson fulminated about the 'demagogic doctrine' which he supposed community artists to believe, neither he nor anyone else was able to decide a foolproof instrument for detecting the presence of this doctrine within community arts groups. The assessment criteria adopted by the Arts Council, and later by the Regional Arts Associations, were never exact enough to penetrate beyond the surface, where the grant applications lay, into the hearts of community artists, and nor could they have been.[10]

Gibson's attempt at redefining the purposes of community arts was not without effect, though, and nor was it a temporary phenomenon which Gibson took with him when he left the Arts Council. The process of redefinition continued long after Gibson had relinquished the chair of the Arts Council, and it still continues today in the various Regional Arts Associations to which community arts has been 'devolved'. Its main effect has been to legitimise the right of funding bodies to *define* the activities they find, rather than accepting them as they are presented and choosing to fund them or not; and the ability of funding agencies to move beyond mere definition to the active *initiation* of projects designed to meet their own criteria.[11] The 'strategy of vagueness' which had resulted from the determined pragmatism of the ACA played into the hands of the funding agencies, who established a small but effective support industry for community arts, consisting of advisory panels, officers and periodic working parties. Ostensibly this industry existed to ensure that the demands that community artists posed were met as speedily, efficiently and fairly as posisble, but in practice it existed to control and direct the

expectations of the movement. The 'strategy of vagueness' took community artists into a period of growth which was *led* by the funding agencies; in which they were the officers and community artists the troops, and during which community artists lost control of the direction of their own movement.

With the advent of an officially approved aim for community arts came an officially approved language by which the work was described. Existing groups learned to write their applications in this language, which was the language of bureaucratic community work, in which 'the disadvantaged' who have 'no chance to enjoy the arts' are encouraged to overcome their passivity for 'their own good'. Community artists learned to stress certain parts of their work and gloss over others, while maintaining a silent cynicism about the business. As new groups came into existence, however, and began to apply for funding, they took as their starting point what they could see and hear; and what they could see and hear was not the actual aims of the existing groups, but their ostensible aims as processed for their annual reports and grant applications. These laundered aims coincided, of course, with the aims the funding agencies wished to fund.

The funding agencies were in part moved by fashion, and their 'areas of priority' and 'target groups' varied from year to year. Fashions did not change as a result of any internal logic, or because previous targets had been met, but as a result of external factors. If a particular year was declared, for example, to be 'International Year of the Disabled' then the funding agencies would attempt to adopt 'the disabled' as a priority, to signal their membership of a liberal consensus; to indicate that they *cared*. However, since the amount of money available did not rise with each change of priority, each change was at the expense of a previous 'target group'. Thus the disabled would not remain a priority till their needs in the arts field had been met, but rather until the funding agencies had 'done what they could'; or in other words until their attention was distracted by an even more up-to-the-minute 'priority'.

The question of what was fashionable in funding played havoc with the way in which community arts groups presented their growth and development in their annual reports. This growth did not appear as a conscious analysis of successes achieved and a thoughtful set of decisions as to how these successes could be sustained and increased, but rather as a set of barely connected leaps having more in common with the developing history of the funding agencies than with the developing history of community arts practice and the community arts movement. It was these apparently unconnected leaps that the new groups saw when they looked at the work that was already being done, and they remained in large part ignorant of the subterfuge which

allegedly lay behind these switches in priorities. As the number of new groups increased, the existing groups began to be outnumbered in a significant way. There came to be more and more groups organised around the criteria espoused by the funding agencies, and less and less groups regarding them cynically. The original groups began to find themselves in the position of being a dissident fringe on the edges of an activity that they had themselves initiated.

Although in the short term, then, the Baldry Report seemed to obtain for the ACA everything that it had wanted, in the long term it backfired spectacularly. It effectively handed the Arts Council the tools with which to reshape community arts. This was not its only disadvantage. Where the Baldry Report *had* mentioned specific characteristics of community arts practice, it had described aspects of the work which subsequently proved to be only transitional emphases. Because it discussed these characteristics, while giving no wider context within which they could be interpreted nor any clear criteria against which they could be measured, it left the clear impression that these characteristics *were* the activity.

This created two separate problems for community artists. Firstly, their work became known for reasons which were tangential to its real purposes. They became known, for example, for providing a kind of extended play facility for children, and in their eagerness to maintain and improve their funding they judged it best not to disagree. Ironically, this sometimes led to a position where those funding the arts thought they should be funded through the education system, while the education authorities saw community arts as a peripheral activity which they had neither the funds nor the inclination to oversee. By a similar process other community arts groups became known as a kind of 'social provision'; the artistic end of community work. So they oscillated uneasily between the clutches of the arts funding agencies and local authorities' social sevices departments.

Secondly, community artists got embroiled in aesthetic arguments, often accompanied by calls for the withdrawal of funding, which were not of their making, and in which they were characterised as believing things which only the most naive would have thought defensible. The *process versus product* argument was turned against community artists who had, in any case, never believed that such a simplistic contrast could be drawn, but had been characterised by the Baldry working party as believing so. Although this notion had a certain stategic utility, in drawing attention to a relationship which had hitherto been largely ignored, it was always unsound in theory and untrue in practice. If you hold wine-making classes and produce only vinegar then there is something wrong with the way that you are doing it. The quality of the product is necessarily one (but only one) of the

ways in which the quality of a process can be demonstrated.

There were only ever a handful of community artists who believed that the quality of the final product did not matter; that an unreadable poster was somehow excused by the fun that had been had producing it. Nonetheless community artists were accused of holding this belief by those who wished to paint them into a corner from where they could be viewed as artistic do-gooders; people of little talent but much compassion. This view suited many officers and members of the Arts Council, for it rendered community artists as lesser, but essential, beings who could be fitted into the current schema. They ceased to be threatening revolutionaries and became instead primitive guides whose role was to lead people through the badlands to the citadels of culture.

In addition to these more or less subtle processes of redefinition, which went on in the wake of the Arts Council's acceptance of the recommendations of the Baldry Report, there was also a series of changes which occurred at a deeper level. These changes were, in the long term, much more damaging, and they resulted, not from anything the Baldry Report did or did not say but, from the whole-hearted desire of the fledgling community arts movement to unite around the attempt to secure funding from the Arts Council.

Community arts, as a movement, therefore allowed itself to be fashioned by its desire to seek funding, and by its willingness to ignore the price that was exacted for that funding – in the form of a progressive loss of control over the direction of the movement and its ability to construct a programme to put its aims into practice. In doing so it turned its back on the possibility of organising around the strengths of community artists, around the collective working methods that were being successfully explored, and which were both its specific contribution to cultural struggle and its raison d'être. As a direct result of the ACA's success in achieving recognition and a budget from the Arts Council, and the way in which it viewed that success, the ACA became a consumer association.[12] It campaigned to improve the size of grants, to improve their availability, and to decrease the amount of stodge in application forms. The problem with this approach was that what was being consumed was state funding in the form of revenue grants, and no amount of tinkering with the prescription by the consumers or their representatives could alter the fact that these grants were to prove to be addictive.

Grant addiction

From the beginning, the community arts movement was reluctant to engage in serious theoretical debate of the sort needed to establish a political framework and a resulting practical strategy through which the work of individual community arts groups might achieve a cumulative strength. This reluctance played into the hands of those pragmatists in the movement who regarded such questions as 'academic'. They were quick to dismiss any such debate as a utopian soft option; a retreat from the 'real battle', which was perceived in terms of the short-term fights to obtain money and resources, to pay decent wages and to 'achieve recognition' for community arts.

Those who argued in this way against 'theory' were not themselves free from theoretical assumptions. How could they be? They had ambitions which they wanted to realise and they imbued their work with a sense of purpose, however intuitively. Yet they were unwilling to discuss their assumptions, and the work that resulted from them, because they believed, as pragmatists always do, that it was not the right moment to do so. The immediate issue, they argued, was the fight to secure adequate funding, and only when that had been achieved could we permit ourselves the luxury of theoretical debate. The irony was that by the time this was anything like achieved the movement had been so constrained that there was little left to argue about.

The decision to unite around the attempt to secure funding from the state was not motivated by greed or a desire for security, however. It was founded on two unargued notions. The first was the belief that the activities of community artists were sufficiently innovative, and of a sufficiently high standard, to justify Arts Council funding, especially when compared to other activities, such as performance art, which the Arts Council was then funding. This argument revealed more about the personal histories and expectations of the majority of early community artists than they might have cared to admit. Whether or not they had ever been art students they had absorbed some of the method of art school. They believed that their activities would some-how be justified by recognition from the Arts Council and the dominant tradition it represented; they believed that institutions like the Arts Council should be expected to be 'fair' in their dealings; and they believed that institutions were just grey buildings from which you

could take the money and run. They believed that it was not fair that performance artists should receive money for doing something which seemed, in many ways, easier than what they were doing.

The second argument, which was the more important, said that the Arts Council's money was, in any case, being wrongly distributed. This money was derived from general taxation, and community artists argued that most working people received nothing in return for their contribution to the Arts Council's finances, since almost all the money which was given out in grant aid of one sort and another was going to the prestige arts. These arts only attracted audiences from a narrow, and quite specific, social spectrum. Since the working classes were not attending the things that the Arts Council was funding, and since they were contributing to that funding through their taxes, the Arts Council ought to change the pattern of its provision to take account of them. Since the bulk of community arts work was at that time being carried out in working class areas, on housing estates and in the middle of cities, then either it should be funded or the reasons for refusing funding should be clearly stated.

This argument was not entirely novel. It was a specific formulation of the much more general argument that no government has the right to appropriate money from people for spending on activities from which they will derive no demonstrable benefit. This argument was successful in that the pattern of spending by the Arts Council was shifted slightly, and a budget was created for community arts activities. But it was a success of a dubious sort.

Community artists believed in various ways that they had a mandate from 'the people' for the work that they were doing. Some believed in the classless Aquarian post-industrial society and talked about giving 'power to the people', while others saw themselves as working with the working class as part of a socialist struggle. Both groups had good reasons to believe that they had a mandate of some sort, for they were working successfully with groups of (mostly working class) people who were normally untouched by subsidised art, and they were beginning to set in motion events which continued autonomously after they had moved on. Because they believed that they had a mandate, nd because the groups with whom they worked were often disgruntled, disenfranchised, or both, community artists believed that in a complicated, and admittedly convoluted, way they were liberating money from the state. They did not believe that their activities were contributing to the growth of the state, rather the opposite. By siphoning money away from it the control of the state over people's lives was being marginally lessened. Within a few years the fallacious nature of this belief was forcefully demonstrated.

As soon as community artists began receiving regular revenue

funding, as they did with the establishment of the Arts Council's community arts sub-committee, they began to be able to work on a more effective, and less piecemeal, basis. As they did this two things happened. Firstly, the demand for their work grew as it became more visible, and secondly, the amount of events which continued as locally organised activities after the community artists had moved on mushroomed. This meant, of course, that the pressure on the available funds grew rapidly, as these local groups themselves began applying for funding. This was a paradox which would grow as the community arts movement grew, and which was not amenable to a merely financial solution; for the more money there was the larger the community arts movement would grow, and the larger the movement grew the more events would be created which would blossom into groups which themselves required funding.

There was, in any case, little internal flexibility in the Arts Council's spending plans, at least in relation to the scale of funding necessary to keep pace with the growth of community arts work, and so community artists were faced with two possibilities. They could either initiate a campaign of open warfare against one or more of the other areas of Arts Council funded activity, in the hope of growing at the expense of one of the other arts, or they could band together with the other funded art forms and fight side by side for an increase in the overall financial provision for the arts. Whether or not the first option was desirable, it was by this point impossible. There was not a single established art form, at that time, which could fail to muster more support than community arts, especially in those areas of power and influence where support would be most necessary. Moreover, any such move would convince the opponents of community arts that they had been right all along, just at a point when the approach of the community arts movement was beginning to gain the credence among other artists and commentators that the pragmatic members of the ACA deemed important. The custodians of tradition, both inside and outside the Arts Council, would unite around the beliefs Lord Goodman had espoused when chairing the Arts Council, when he had questioned whether it was the duty of the state actually to subsidise those who were working to overthrow it; for a frontal assault on the traditional art forms, on 'our cultural heritage', would inevitably be seen as an attack on the state.

The only viable alternative was to join forces with those traditional bourgeois art forms and campaign, on the Arts Council's behalf, for more money. Theoretically, the community arts movement had been telling itself, the money it was getting was plundered from the prestige arts, but this was soon revealed as a naive fantasy. The money for community arts was 'extra' money, made available to the Arts

Council as 'development money', and made possible by the credit-based economic boom through which Britain was passing. Our position was such, then, that we might need to fight for an *increase* in taxation in order that the Arts Council might receive more money, so that community artists might give more of it back to 'the people'. We had placed ourselves firmly on the side of those who would increase the size, scope and hence power of the state, while priding ourselves on the fact that we worked with people who were suffering from the domination of the state; people who were unemployed, inadequately housed, poorly schooled and unprovided for in terms of recreational facilities.

There was at the time no consensus on these issues among community artists, because there was no shared theory and no shared language of the sort that would have been needed in order to begin a discussion. The result of the decision made early in the life of the Association of Community Artists to organise primarily around the need to obtain funding led directly, if somewhat paradoxically, to the movement's inability to deal with the contradictions it encountered when that funding was forthcoming. The movement was eclectic and prided itself on the eclectisim. It was as broad based as it could conceivably be in order that the campaign for more and more funds should be as large and as loud as possible. The consequences of this, once we had entered the citadel, was an almost complete inability to discuss what we had found there, except in the language and categories of those already living there. We came as invaders, but without a language of our own we were soon acting and talking like the natives of the citadel.

In order to show our good intent, and as a way of dealing with the subtly changing assessment criteria, community arts became the welfare arts. We no longer spoke, as a movement, of working with the working class, or even with 'the people', but instead we began to talk of working with 'the most deprived sections of the community'. By describing our activities in this way they became more recognisable to funding agencies; not just the Arts Council, but to other state agencies whom we were beginning to approach, the social services departments and the education authorities. Our activities became comprehensible to these agencies, without appearing hostile or threatening, because we had delineated our customers, our services and our fields of operation in terms which *they* had defined, and which they both understood and controlled.

The effect of this was clearly paradoxical. The original impulse behind what came to be community arts had been the desire, noted earlier, for a liberating self-determination through which groups of people could gain, or regain, some degree of control over some aspects

of their lives, and the parallel realisation that an artistic practice could itself be a form of cultural activism. The way in which this practice had been established, however, meant that it was, in many areas, likely to *lessen* the self-determination of those people with whom we worked. We were arriving more and more, not as activists, but as quasi-employees of one or another dominant state agency. We were, in effect, inviting people to let one branch of the state send in a group of people to clear up the mess left by another branch of the state, while at the same time denying that we were working for the state.

Moreover, it was not just our description of our work, nor the nature of our employment, that we were changing, in our growing addiction to revenue funding. We were in fact constructing community arts groups in such a way that they could *not exist* except through revenue funding on an increasing scale. All thoughts of taking the money and running disappeared as groups expanded to claim the money available. The number of workers grew, the amount of equipment grew, and with them grew the dependence on state funding. Since this happened a small step at a time seemed a 'natural' and inevitable part of the development, and maturation, of community arts. Once the money started coming, and once we had arranged our activities so that we were dependent on it arriving in increasing quantities, it became essential that we commit ourselves to keeping the supply lines open. It became important that our voice was heard within the Arts Council, and it came to seem vital that we secure the maximum possible representation on the Arts Council's Community Arts sub-committee. Many people associated with the community arts movement (myself included) sat on the committee and spent many unpaid hours engaged in the assessment of clients and applications or the internal politics of the Arts Council.

Because of the dependency that we had ourselves helped to foster we could not see what a waste of time this was. Experienced community artists tied up major parts of their time engaged in exercises which were at best diversionary and at worst positively damaging. Every year the committee straight-facedly assessed each application and visited each applicant, and then produced reports which led to an agreement by the committee on a sum of money which would represent the 'assessed need' of community arts in Great Britain. This figure was submitted to the Council of the Arts Council where it formed part of the information they used to calculate their overall requirement, which they communicated in turn to the Department of Education. Every year the Arts Council received less than it asked for and the Community Arts sub-committee received but a small percentage of what it 'needed'. There then followed a second round of meetings in which we would agonise over who to cut, whose

grant to increase, and which one or two new clients to let in. Every year we put in an enormous amount of work in the belief that we could affect some control over something that was always out of our grasp.

Arguably all of this did little harm; it was merely a way, intentional or not, of diverting the attention of a number of community artists by showering them with unpaid work, apparent power and free lunches. Unfortunately it extended further than this, for although the committee meetings may have been harmless, the assessment visits on which they were based caused the movement grave damage. For in order to carry out its assessments the committee had to develop some criteria by which it could compare the various projects its members saw. It then required the community artists on the panel to assess other community artists on the basis of these criteria. Although the committee always claimed that these criteria were in no sense an attempt at *defining* community arts, the claim was hollow. These criteria related to no other definition, for there was no definition that had been debated and agreed by the movement, and so they became, by default, the only definition there was. They had been constructed from a set of proposals submitted by those members of the ACA sitting on the committee, with reference to the recommendations of the Baldry Report, and they took the form of a series of general questions which applicants might be asked. Although some of these questions had originated with community artists on the committee, they had been constructed, in the pragmatic tradition of the ACA, so that the Arts Council would find them acceptable. In this way applicants were encouraged to think about their work in terms of a set of questions which served the purposes of the funding agency, yet were legitimised by the fact that they had ostensibly been written, and fought for, by community artists.

Pragmatism had led the community arts movement into an almost total dependence on revenue funding from a very few sources, and the movement, with the addict's desperate need to protect the source of supply, tangled itself into a hopelessly complex web. Not only had it failed to define its own tasks, it was now campaigning to get its own members onto a committee from which they could propagate a definition created by, and serving the needs of, their supplier. It was ceasing to be a movement of activists and beginning to become a profession.

Chapter Five

The professionals

During 1978 the precise status of the Association of Community Artists was the subject of much debate among its members, who had mostly shaken off the disorganised eclecticism of the (exceedingly brief) age of Aquarius and had come to a variety of consciously 'left' positions, mostly socialist. Some members advocated that the ACA should seek to affiliate to the TUC as a union, while others argued that community artists should unionise individually, or group by group, leaving the ACA as a campaigning body. A third group suggested that the ACA should be 'opened up' to the people with whom community artists worked, and that it should act as an information and 'consciousness-raising' organisation for all those interested in community arts.

The steering committee of the ACA had applied to the Arts Council and to the Calouste Gulbenkian Foundation for funding, since there was some feeling that the association needed a paid coordinator.[13] The funding agencies then entered the debate about the ACA's structure in a way which proved decisive. They argued that the ACA was a 'political body' which they could not fund, and indicated that they would be keen to fund its educational and information aspects if these were separated into an organisation of their own.[14] True to its history, the ACA made a pragmatic decision to fit in with the funding agencies' ambitions for it, and so it began moves to set up a national organisation, registered as a charity, which would operate as an education and information resource, and whose membership would be broadly based. This was established in 1980 as the Shelton Trust, when it received a grant so small as to render it invisible.[15] The ACA itself dissolved as a national organisation, and became instead a federation of regional associations, each of which was able to constitute itself as it saw fit. This was done in the expectation that these regional associations would be coordinated by the workers of the Shelton Trust, who would pool the information from the regions, organise regular national meetings and host conferences, In effect it was the end of the ACA as a national body, and a national force.

The national steering committee advised the ACA members to unionise on an individual basis as members of ACTTS, which is part

of the Transport and General Workers Union. This was a decision which sent community artists further down the road of profession-alisation, since it was a recommendation to unionise around a job title, rather than around any material skills. It meant that community printers would attend union meetings where they would talk to community workers, community photographers and other fringe professionals. Although this might have the advantage of offering companionship it presented none of the political opportunities that would have existed had we unionised on a craft basis, so that community printers talked to industrial and commercial printers as fellow workers.

That these opportunities are real can be seen by a comparison with the fate of radical film-makers, who were unionised by the film union ACTT in the 1970s. After a few years' struggle they persuaded the 'mainstream' film technicians of the possibilities of producing films for cultural reasons and for reasons of political struggle, as well as for profit. As a result of this they were able to get the union to recognise the notion of cultural production, and its importance in socialist struggle, and to alter their codes of practice to accommodate this view. In place of the single, strictly demarcated agreement that ACTT had previously offered employers, a set of agreements were drafted which would be offered according to the cultural purpose of the film being proposed. These agreements ranged from the traditional one, which continues to apply to commerical film-making, through to a 'workshop agreement', which applies to certain radical practices, and which allows for complete job flexibility and collective working. This was only possible because the radical film-makers had been unionised on the basis of their skill, and were thus talking to people who shared that skill, while not necessarily sharing their motivations. It was not possible where unionisation occurred on the basis of job titles and sources of funding: the 'voluntary sector' was left talking to itself to little political purpose.

In May 1980 the Arts Council and the Council of Regional Arts Associations published a joint paper, *Towards a New relationship*. This paper, which was in part a response to the report published the previous year by an Arts Council Organisation Working Party, examined the ways in which the Arts Council and the Regional Arts Associations worked together. It made a series of recommendations, the major one of which was the 'devolution' of a number of arts activities from the Arts Council to the Regional Arts Association in whose area they took place. Among the activities suggested for devolution was community arts. The process of devolution took place between 1979 and 1982, as agreements were negotiated by the Arts Council and the various RAAs as to how they were going to manage

and administer the devolved activities. Northern Arts, North West Arts, West Midlands Arts and Merseyside Arts were the first four to be devolved, although in some cases devolution was spread over a number of years in order to let the RAA 'grow into' its new expanded role.

Devolution highlighted the position of helplessness reached by the ACA at the point of its dissolution. As a consumer association its powers were exceedingly limited, especially since, there being many more applicants than funds available, it existed in a seller's market. It could do nothing about the fact of devolution, although many community artists saw it as potentially disastrous for the growth of the movement. All it could do was make complaints and suggestions about the specific terms on which devolution was being 'offered'. Thus the ACA in the West Midlands exploited the fact that the Community Arts Committee at the Arts Council had decided that devolution should not happen without the consent of the community artists in each region, and refused to accept it. As a result they received an improved offer (that is, slightly more money was offered to the region for 'new initiatives') which they also rejected. Most groups went so far as to return the grant cheques they were sent. Their second refusal was as unable to alter the basic threat of the Arts Council's policy as their first, although it raised some eyebrows and resulted in yet another improved offer to West Midlands Arts. It was made clear to the community artists that this was as much as they were going to get, and on the basis of the second offer, devolution went ahead.

Later, it became clear that the 'extra' money that the West Midlands had won was not really extra money at all. The Arts Council had budgeted for the overall cost of devolving community arts, and had simply rearranged the distribution of that budget slightly in order to get the process moving. In effect, as each region was devolved it fought for as much as it could get, and the more it got the less there was for each succeeding region. Those at the start of the queue were able to bargain only because of their ability to hold up the entire procedure; those at the end of the queue had nothing to bargain with, and got very little.

The main fear that community artists felt about devolution was that the national nature of the community arts movement would be lost and would be replaced by a set of uncoordinated regional initiatives. Whatever the dangers of operating under a set of definitions created by the funding agency, at least community artists had all hitherto been operating under the same definitions. Now, it was felt, there was a real possibility that nine or so separate definitions would evolve, so that the term 'community arts' would mean something entirely different in

Bradford from what it meant in Bath. Although the Arts Council claimed to recognise this as a problem it was not a problem on which it was prepared to spend much time or money. It effectively contracted the problem out by assisting in the formation of the Shelton Trust, and by arguing that it was the role of a national educational charity such as the Shelton Trust to draw the strands of the now regionalised movement into a coherent whole. This task was almost impossible, however, for what determined the way in which community artists in each region organised themselves was the way that the Regional Arts Association defined community arts and the way in which it was incorporated into their overall pattern of activities.

By 1982 devolution had been completed, and the Arts Council had almost entirely ceased funding community arts directly. The Regional Arts Associations had almost all appointed community arts officers, who saw it as part of their task to interest other funding bodies in community arts. This they did with some success, and many local authorities and metropolitan authorities took community arts on to their leisure or recreation programmes. Perhaps the most spectacular example of this was the newly elected GLC's decision to set up a community arts committee, as part of its arts and recreation programme, and give it a budget in its first year of over £1,000,000. At the start of the 1980s the Manpower Services Commission also became interested in community arts, as a basis for organising its Youth Opportunities Programme. As Bernard Ross, then chairing the Skelton Trust, argued in *Another Standard*, there was evidence to show that the MSC rapidly became the largest funding body for community arts in this country.

This rapid expansion of funding took place as a result of initiatives by funding agencies who, for reasons of their own, wished to fit community arts into their overall programme. In the case of the Manpower Services Commission community arts was seen as a quick and easy way to start projects which could find enough work to keep everybody busy, and yet required little capital investment. The solution to the growing number of unemployed teenagers was to be: let them paint walls. This expansion served to demonstrate forcefully the impotence that had resulted from the community arts movement's decade of grant addiction. Having organised itself pragmatically, with no theoretical or political framework, it was unable to insist on, or even suggest, a set of definitions, criteria and emphases which these newly interested bodies should adopt. This was a lost opportunity of major proportions, for at least some of the new funding agencies, such as the GLC, had indicated that they were ready to build on existing practices and help existing philosophies develop. In the event, it was left to the funding agencies to decide for themselves what it was that

they wished to recognise as community arts, and what they wished to fund. The definition of a community arts project then became a simple matter: if it was being funded as a community arts project then it *was* a community arts project. In this way community arts became a buzz word; a piece of jargon meaning nothing that could be used by the chairperson of any council recreation committee to put a radical sheen on what had previously been their miscellaneous spending.

It also served to ensure that community arts would be seen as a profession, and thus concluded a debate which had been argued over for several years. It had been argued by some community artists that in relying almost exclusively on state funding for its growth and development community arts had allowed itself to be changed from an area of shared cultural activity, which was avowedly partisan, to an area of neutral professional concern, within which it was *possible* to be radical, but no longer obligatory or even helpful. However vaguely community artists had defined their actions they had mostly nursed the desire to help achieve a movement within society towards equality of opportunity, social justice and communal self-determination. These aspirations were, in political terms, left-wing; and sprang from ideas about the nature of organisation and power within society which were also left wing. Now that community arts was established as a legitimate area of state concern there was no longer any reason why this should be so, and indeed, given the aura of neutrality with which the state's activities are cloaked, every reason why this should not be so. The state legitimises its activities by claiming that they are impartial, and designed to take account of the feelings of all groups within society, and therefore presents the sevices it controls and coordinates as equally impartial.

Richard Hoggart, while an influential member of the Arts Council, went on record as saying that he could see no reason why there should not be right wing community artists, and that although personally he was left wing, he would be in favour of funding them in order to provide a clear demonstration of the Arts Council's neutrality and its independence of government. In the report of the ACA conference held in Barnstaple in March 1980, Oliver Bennett, then the community arts officer for North West Arts, wrote about the advantages of a confidentially appointed community arts committee which, unlike an elected committee, could be assembled so that it 'ensures a proper balance of interest. This effectively avoids the domination of one particular approach to community arts work'.[16] What it actually does, of course, is signal the demise of community arts as a radical, partisan activism and herald its arrival as one of the caring professions.

The transition from activism to professionalism can be seen in its

completed form in community work, which has moved from unpaid and unrecognised activism to direct employment by social services departments. Although the Association of Community Workers has many politically committed members, it is neither their membership of the association nor their commitment which defines them as community workers; it is their professional qualifications gained on a licensed course at an approved institution, or the job description given to them by their employer. Within this job description it is possible to contain almost any political perspective, any philosophical outlook whatsoever. Community workers of diametrically opposed views can work alongside each other precisely because state funding has rendered the area of work neutral; and the power of their employer to define that area, and to control that definition, has rendered their political views 'private'. It is no longer *their* politics which inform their activities, but rather the politics of their employers. Their own politics have become incidental to their work; as important as their choice of toothpaste or the brand of muesli they eat.

In community arts this transition is not yet completed, but its completion is now under way. Community arts may now be *seen* as a profession, but it has not yet finally and irrevocably become one. The final hurdle to the professionalism of community arts is *training*, and it is this which is now recognised by the funding bodies as the important area of development. Numerous papers have been produced and discussed with the Arts Council and the RAAs, and 'training seminars' have been held to discuss how to institute training programmes. These have been matched by the desire of a growing number of art colleges and polytechnics to take community arts on board, and to offer it either as an option within existing courses or as a course in its own right. The thrust of these arguments can be seen as a paper presented to an Arts Council/CORAA combined arts planning meeting, in September 1983, by Liz Mayne, the combined arts officer for North West Arts. This paper argues that there is a need for a permanent community arts course since 'there has been an upsurge in interest and acknowledgement as to the value of community arts, in particular from local authorities', and although 'new job opportunities are being created . . . there is an acute lack of experienced community artists to fill potential posts'. She offers an outline of the 'essential ingredients of the course' and proposes that a feasibility study should be run at Leicester Polytechnic so that 'depending on the findings of the study, a permanent course can be aimed for in 1985/86'.

It can clearly be seen that 'training', in the sense in which Liz Mayne is defining it, is not a problem for the community arts movement. Rather it is a problem for those funding agencies that, having decided to fund community arts, cannot find enough people to fill the posts

they have in mind. As soon as the funding agencies have successfully devised their strategy for closing this gap, and as soon as those students have certificates authenticating them as community artists, then the history of community arts, as it has been practised in this country to date, will have finally finished. Community arts will have emulated community work in becoming a profession with a hierarchy of trained and untrained workers, in which the training is centrally controlled and functions as a closed orthodoxy. Those who began community arts, and who sustained and developed it, will come to be regarded as untrained old-timers, with little place in the modernised and regulated community arts career structure. If this happens, then we will have been conspirators in our own demise. In refusing to look at our history and to recognise the mistakes that we have made, we will have handed over our activism to another group of people so that they can process it into something more respectable and then (if we are lucky) sell it back to us. If we are to extricate ourselves from this web, then we have very little time left. We must achieve an understanding of the position at which we have arrived, and the ways in which we have been led there. Based on this understanding, and on a knowledge of the political framework within which the community arts movement operates, we must devise a practical programme which will clearly link our day to day activities with our long term goals.

Notes

Chapter One
1. See, for example, Marshall McLuhan, *Understanding Media* (Picador) and *The Medium is the Massage* (Penguin); Timothy Leary, *The Politics of Ecstacy* (Paladin); Alan Watts, *The Book against the taboo of knowing who you are* (Abacus); as well as such books as Abbie Hoffman, *Steal This Book*, (Pirate Editions); Jerry Rubin, *Do It* (Jonathan Cape), Bobby Seale, *Seize The Time* (Bantam).
2. The Arts Council of Great Britain was begun in 1945, to carry on the public subsidy of the arts that has been carried out during the Second World War by the Council for the Encouragement of Music and the Arts (CEMA). Its budget for its first year was £157,801. Its headquarters are at 105 Piccadilly, London W1, although until the middle of the nineteen fifties it had a number of regional offices.
3. For a much fuller description of David Harding's work, see Su Braden, *Artists and People* (Rutledge and Kegan Paul).
4. There is a description of the beginnings of West London Media Workshop, and a number of other groups like them, in Heinz Nigg and Graham Wade, *Community Media* (Regenbogen-Verlag, Zurich).
5. Taken from an interview with Martin Goodrich, a founder member of Free Form, in *Another Standard*, Winter 1982.

Chapter Two
6. Taken from Appendix 2, *The Report of the Community Arts Working Party, June 1974* (Arts Council of Great Britain).
7. There are twelve regional arts associations covering respectively: East, East Midlands, Greater London, Lincoln and Humberside, Merseyside, North, North West, South, South East, South West, West Midlands and Yorkshire.
 Although South West Arts Association began in 1954, and a Midlands Association was formed in 1958, the main period of development for this form of arts administration was in the late 1960s, following the White Paper *A Policy for the Arts: The First Steps*, which was produced by the new Labour Government after the 1964 general election. This proposed a decentralisation of the functions of the Arts Council, and an increasing involvement, both financially and politically, of local authorities within the area covered by each RAA.
 A decade later, the Arts Council helped produce another paper, *Towards A New Relationship*, which recommended a further round of 'devolution'.
8. Clause 3 of the revised Charter of Incorporation (1967) states that the 'objects for which the Council are established and incorporated are as follows:
 (a) to develop and improve the knowledge, understanding and practice of the arts;
 (b) to increase the accessibility of the arts to the public throughout Great Britain; and
 (c) to advise and cooperate with Departments of Our Government, local authorities and other bodies on any matters concerned whether directly or indirectly with the foregoing objects.'

Chapter Three
9. Taken from an interview in Heinz Nigg and Graham Wade, *Community Media* (Regenbogen-Verlag, Zurich).
10. Although the Regional Arts Associations did not adopt a strictly uniform set of criteria, the differences were, by and large, differences in emphasis. These

related more to the overall structures of the various associations, their internal politics, and the personalities of the people involved than to any argued views as to what community arts actually was.

11. The 1984 Gulbenkian Foundation Community Arts Apprenticeship scheme is a current example of this kind of initiating activity. The scheme is not, in any sense, a response to a grassroots demand. Instead it arose from a belief among officers of the various funding agencies that there was a 'need' for training facilities. As a result the Gulbenkian assembled a working party which met and, having agreed there was such a 'need', recommended that money be made available to establish a series of apprenticeships. It was at this point that the Gulbenkian approached community arts groups to ask who would like an apprentice for a year.
See also the discussion on 'training initiatives' in Chapter 5.

12. The Arts Council was not the *sole* funder of community arts activities. There had always been a number of trusts and charities eager and willing to fund work in this area. The Calouste Gulbenkian Foundation, for example, was involved in the early development of community arts, and maintains its involvement to the present day.
 However it was the Baldry Report which most clearly shaped the aspirations of community artists, and which most directly determined their future. Moreover it was the achievement of recognition by the Arts Council, and the revenue funding which that was felt to entail, which at the time was regarded as the key victory by many in the community arts movement.

13. Some indication of the way in which the community arts movement was moving from notions of activism to notions of professionalism can be seen here. Some community artists suggested that the coordinator might be funded from within the movement, by an increase in the levels of subscriptions to the ACA to something more nearly approaching the level of union dues in crafts unions. 500 community artists, each paying 50p per week, would provide an association with an annual income of £13,000. This suggestion was dismissed by the steering committee as 'naive', and as something that community artists either could not, or would not, afford. Instead, it was argued the movement should press the funding bodies to provide money to employ a coordinator.

14. In this process it was the Gulbenkian Foundation, under its director Peter Brinson, who set the pace, and who persuaded the Arts Council to join them in supporting and funding what was to become the Shelton Trust.

15. The Shelton Trust has recently begun to move from its uncertain beginnings, and to establish a role for itself. It is a membership organisation which organises quarterly seminars and publishes *Another Standard*. It can be contacted at The Old Tin School, Collyhurst Road, Manchester M10.

16. *Principles and Practices*, a conference report (Shelton Trust).

Part Two

A political framework for community arts

The state

A large part of the history of the community arts movement is the history of its direct and indirect relationships with the state. Agencies of the state, whether quangos or local government departments, have been its largest and most regular sources of funds. The relationship between these agencies and community artists have themselves been governed, or at least constrained, by the functions of the various state agencies, and ultimately by the nature of the state itself. Through a long and complex process, the state has assumed the role of patron of the arts, and custodian of a specific national culture, and the establishment of the Arts Council of Great Britain in 1945 is but one example of the ways in which the state enacts that role. The establishment of the the BBC and later the IBA, and the regulatory frameworks within which they are required to operate, provide other examples, as does the establishment of the Sports Council. The state has also assumed the role of 'director' of this national culture through its ability to emphasise or constrain activities by means of funding allocations and licensing restrictions. This ability enables it to construct a specific dominant culture, while apparently dealing evenhandedly with all cultures and favouring none.

In order to build a political framework which will place the history of the community arts movement within a larger and yet comprehensible context, we need to look first at the roles and functions of the state. It is outside the scope of this book to present a complete theory of the state, and its relationships to other determining agencies such as economics and ideology. I shall attempt only to provide a picture of the state as a medium within which the power of government, and other powers, operate.

For our present purposes, we can say that the state in broad terms fulfils four functions. Firstly it has a directive role in which it encourages and propagates a consensus about what constitutes the national interest. This it does through a stick and carrot process, involving grants, concessions, licenses and regulations. Secondly it has a protective role, where it acts to maintain the status quo through the development of such institutions as the police force and the army. Thirdly it intervenes in the economy in both positive and negative ways, ranging from nationalisation and privatisation through to the

enforcement of certain procedures in both manufacturing and business practice. Fourthly, it has an external role, in which it defends the consensus view of what constitutes our 'national interest' against what other nation states see as their national interests.[1] I shall be concerned here with the first two roles, which I have described as directive and protective; for it is, I believe, in these functions that we can most clearly find the patterns of state behaviour which are relevant to the kind of cultural activism to which the community arts movement aspires.

The state affects each of us every day, and although we can change our attitudes to the way that it affects us, we cannot opt out of its effects. It is a truism, but not an unimportant one, to say that our membership of the society that the state oversees is not voluntary. The various agencies of the state assume powers of compulsion, and the laws through which this complusion is channelled affect and modify our behaviour, whatever we think about them. This does not mean that the state is some kind of all-powerful Leviathon. In fact it is not any kind of object at all; not even a simple abstraction in the way that a limited company or a football club are. It is a system of relationships, a method of patterning and organising social action which is being modified every day. It has been assembled slowly over time, through the constant modification of behaviour, action and methods of compulsion, some of which were planned and some of which were unplanned or had unforeseen consequences. It is still, through daily modification, being assembled and reassembled, for it is not a process which can ever be 'finished'.

Though it is a system of relationships constructed partly by design and partly by accident, it is not a random system. Moreover it is not a system in which everybody is free to participate equally; it has been built by the most powerful groups in society to reflect what they perceive as their interests. The ways that these interests are reflected is itself complex, since the state is not monolithic nor even always consistent in its activities. There is always the possibility of what Raymond Williams has termed *asymmetry* between different state activities or functions.[2] This asymmetry has developed partly because the state, as it has grown, has had to respond to a diverse set of pressures, including the demands of the working class, and more recent sectional interests, such as women and 'ethnic minorities'. The state has therefore grown into a complicated network of related organisations with varying degrees of apparent autonomy, which will at times seem to be hostile to the interests of some of those powerful groups who are largely responsible for the present form and organisation of the state. It remains true, though, that the basic principles and motivations which fuel the network of the state still

belong to the most powerful groups in society. Although the state is not a Leviathan-like machine, neither is it a neutral and passive instrument. It is a series of active relationships between organisations; and a way of organising those relationships which are rooted in specific assumptions and beliefs.

This can be seen in a number of ways. Society is, in part, composed of a large number of people doing jobs, and a dominant view about the nature and value of the jobs they are doing. This view is both coordinated and propagated by the state. Different states, or the same state at different times in its history, will place markedly different emphases on the various aspects of work; on the relative social benefits of productivity and safety for example. These emphases will be indicators of the dominant values of the state, and of the consensus which it is engaged in fostering. In this society, the security of even the most productive (in normative terms) of jobs is not entirely dependent on continued productivity; not in principle and not always in practice.

There was, for example, during the 1970s a sizeable number of cases of 'asset stripping'. This occurred when certain financiers realised that the assets of some businesses were technically undervalued to the extent that they would realise a large profit faster if they were broken up and sold off than if they were kept in productive use. Asset stripping was not to do with profit and loss in the usual sense. It was to do with two different ways of raising profits from the same assets, one of which would effectively provide a short cut to wealth. The process occurred, therefore, even where the business being stripped was already making a profit, and could have been reasonable expected to continue to do so.

Under the current arrangements of the state, asset stripping is legal; which is to say that the law does not concern itself with the extra-financial aspects, or the social consequences, of the act. These are a matter of 'private' conscience. If, however, the employees of such a company, who would face the consequences of asset stripping in the form of sudden and involuntary unemployment, tried to intervene by occupying the factory to protect their jobs, and the wealth that they had helped create and sustain, they could be removed as trespassers and prosecuted. It is easy to see here that the state is not neutral; that whatever anyone's intentions, the interests of one side are served by the law while the interests of the other side are not.

Some community activists, including many community artists, have suggested that this lack of neutrality can be used to advantage. They argue that the state can be turned around like a cannon, and made to fire the other way. The working class can take over the state, and then use it to do what *they* want; to get rid of oppression and

inequality. I do not believe that this is possible, in theory or in practice. The state is not a machine whose ownership can change hands, and nor is it some sort of structure which can be vacated by one side and subsequently occupied by the other. It is at once a system of relationships, and a series of agencies acting on those relationships. These relationships are a major determining factor on our lives, and place limitations and constraints on our expectations. Far from being vulnerable to acts of simple opposition the state is already determining the kinds of opposition we will have. It is doing this by processing radical activism into the kind of certificated and licensed professionalism that can be incorporated into a controlled career structure.

In describing the state in this manner, I am not suggesting that it is an 'artificial' imposition, which prevents us from reaching some sort of 'natural' freedom. Social activities necessarily consist of restraints and limitations, from such obvious and external constraints as the inability of one person to park a car in the space another person has already taken, to the more subtle, and internalised, constraints of language and perception. The centralised state is one method of imposition which could only ever be replaced by another method of imposition. Not all methods of imposition have the same effects on those who live under them, however, and not all have the same historical consequences. It is certainly not true to say that, because limitations and constraints are inevitable, the forms that they take are unimportant. The modern state is a particular historical formation under which community arts has grown and developed, and any political framework for community arts must be aware of the *specific* constraints that are imposed upon it by specific systems of relationships.

The state cannot be *abolished* for the functions which it performs are necessary functions. It can, however, be *transformed*. As Andre Gorz has pointed out, the problem is 'the abolition not of the state but of domination'.[3] The specific structures of the centralised, and centralising, state 'are called into being by social relations of domination (the domination of one class over society as a whole) which they themselves extend and consolidate'. In the arguments that follow, therefore, I am not arguing that the state must in some way be defeated. Rather, I am arguing that it must be reduced in order that activity in other spheres can have space to grow.

The state, as I have briefly outlined it, is itself only part of a wider network of social discourses, which are mutually interactive and in a constant interplay. Among the other relationships which form a party of this wider network is that set of relationships described by the term *community*, and the ways in which community interacts with the state

are of primary concern to any attempt to construct a framework within which to locate community arts practice. It is within the area of this interaction that most of our work takes place.

Chapter Seven

Community

The term *community* has been central to the development of those strands of radical activism which have, over the last decade, been concerned with decentralisation or self-determination. It has also, however, been a confused term which has often been used as a badge to indicate a general sympathy for the idea that 'small is beautiful', rather than as a word with a precise meaning. Although it has been used in this loose and general way it is not without meanings, and these meanings can be traced back through a history of English socialism. To develop a political framework for community arts we must examine this history, and the meanings which this history has attached to community.

There is a strong British socialist tradition which maintains categorically that sovereignty cannot be assumed by the state, or any other institutional agency, except on a strictly monitored and temporary basis, and that in all other circumstances sovereignty should remain with the people, who should be free to meet their own needs, and free to band together to meet their own collective needs. This tradition, which may be traced back as far as Winstanley's *The True Leveller's Standard Advanced*, has included the Oddfellows, the original friendly societies, the Rochdale Pioneers and the cooperative movement which followed them, and the guild socialists.[4] It has been documented by writers ranging from AJ Penty and GDH Cole to Raymond Williams and EP Thompson.[5] For the last hundred years, however, this tradition has been under a sustained attack from the growing forces of centralism, both right wing and left wing, and since the Second World War it has been virtually eclipsed by the rapid growth of the corporate state, with its emphasis on centrally controlled and bureaucratically directed provisions and services. Technological innovations, particularly in the areas relating to the almost instantaneous transmission of information and commands, have permitted more and more decisions to be made from a single centralised source. The increasing sophistication of data storage and retrieval system has permitted authorised decision-makers to increase greatly the number of people into whose lives they may directly intrude.

This has led some people on the left, including some cultural activists, to argue that the notion of community, as it has been

variously understood, is now outmoded, and that an attachment to it is necessarily romantic and whimsical, like an attachment to steam trains or gas lamps. They argue that the centralised state apparatus is an inevitability, and that the job of the left is to seize this apparatus on behalf of, and for, the working class. This argument ignores two points. Firstly, it arises from what I have referred to as the belief that you can point the cannon in the opposite direction, which assumes that the cannon itself is merely a neutral instrument which will serve whoever owns it. While this may be true of cannons, it is certainly not true of an agency like the state, which plays an important part in determining the expectations of those who would seek to control it by the imposition of its own rules and conditions. Secondly, this argument makes the assumption that the state has somehow become the only agency capable of fulfilling the task of meeting people's collective needs, and that no other agencies do, or could, exist to do this. Unless this can clearly be shown to do so, then this argument will lead us into arguing for more and more nationalisation of a merely formal kind, in which 'the people' or 'the working class' attain a tenuous and nominal ownership of industries, services and agencies which, in reality, remain under the firm control of an almost autonomous managerial class.

It must be realised that the domination of the centralised state, through the ideology it embodies and the programme it enacts, constitutes one of the major obstacles to achieving the kind of democratic and equitable access to the means of cultural production which community artists have claimed as their ultimate aim. The domination of the state, which has come to be both centralised and centralising in its actions, stands in opposition to the establishment of community, where community is understood as shared activities and goals, and not as the sort of theoretical abstraction which social services departments like to refer to as 'a community'. This kind of community is simply a statistical unit large enough to be designated as requiring 'development'. The kind of community to which I am referring, on the other hand, is an active and self-conscious process. For a group of people to be defined as this kind of living community it is not sufficient that they live, work and play in geographical proximity; nor that to an observer they have habits, goals and achievements in common. These are necessary conditions, perhaps, but they are not on their own sufficient, for it is also necessary that the members of a community acknowledge their membership, and that this acknowledgement plays a recognised part in shaping their actions. Thus although the preconditions for the formation of community are of an objective nature, the formation of community, and its subsequent growth, are by nature subjective.

Community then is not an entity, nor even an abstraction, but a set of shared social meanings which are constantly created and mutated through the actions and interactions of its members, and through their interaction with wider society. In the words of Raymond Williams:

'Our descriptions of our experience come to compose a network of relationships, and all our communications systems, including the arts, are literally parts of our social organisation. The selection and interpretation involved in our descriptions embody our attitudes, needs and interests which we seek to validate by making clear to others. At the same time the descriptions we receive from others embody their attitudes, needs and interests, and the long process of comparison and interaction is our vital associative life.

Since our way of seeing things is literally our way of living, the process of communication is in fact the process of community: the sharing of common meanings, and thence common activities and purposes; the offering, reception and comparison of new meanings, leading to the tensions and achievements of growth and change.'[6]

Community in this sense is obviously not available for 'development', in the sense that funding agencies and government departments use the term, nor is it available for 'management' by external agencies, however benevolent or well-intentioned. Community grows as its members participate in, and shape, its growth; and it grows because of its members' participation. It is an act of oppression, therefore, to attempt to 'work with' a community as part of a directive, professionalised role, since this will impose an externally manufactured shape and direction upon community which people will be invited to accept as their own, and encouraged to act upon as though it were their own.

Similarly it makes little or no sense to talk glibly about 'the community on such and such estate', since any housing estate will, in reality, contain a multiplicity of interlocking communities, interacting within a complex and continuously changing network. We can only speak realistically about community growth where it is self-directed and internally controlled. Those 'communities' which have been manufactured by directive professionals, whether community workers, detached youth workers or community artists, to fulfil their own professional needs, do not interlock with other communities and nor do they change and develop internally. Instead the opposite occurs; they ossify a specific set of relationships which have the professional at their centre, and they continue only as long as the professional remains at their centre. Thus neighbourhood councils are often constructed around the workers who are allegedly their servants,

and the professional coordinator becomes the manufacturer of that which they will 'coordinate'.

The self-directed and internally controlled activities of living communities can take two forms: the *protective* and the *expansive*. Protective acts will aim to protect, nourish and maintain those minimum social meanings and resources without which community would be impossible. Protective action, therefore, covers many of the areas in which community arts and community work take place: the maintenance of reasonable living conditions, the satisfactory provision of entitlements and services, and the establishment and maintenance of basic communal facilities. Protective action is concerned with ensuring that members of the community receive the benefits and provisions to which they are entitled, and that these are both sufficient and satisfactory. The definitions of sufficient and satisfactory will necessarily be normative, and not based around any fixed quantities or external verities. The point is to ensure that communities have sufficient relative to the wider society in which they participate, and more specifically to ensure that they have sufficient in order that they *might* participate in the wider society.

Expansive acts, on the other hand, will aim to encourage and expand social meanings wherever they are strong. They will move beyond the determinist fallacy of seeing people *solely* as the products of a given, and pre-existing, culture, and take into account their role as co-authors of that culture. People are constrained within limitations, but they are capable of changing and expanding those limitations; of pushing against them and making them move. People are not capable of abolishing *all* constraints, and still less of abolishing the fact that constraints exist. But it is not just a naive voluntarism to assert that they *are* capable of changing the specific constraints under which they live; of struggling to change one set of constraints, with one specific set of consequences, for another set, with an altogether different set of consequences. The expansive action of living communities will be concerned with just this kind of change.

Once we adopt this dynamic view of community and see it as an oppositional tool in the struggle with the specific limitations forced on us by the centralised and centralising state, then it becomes a goal, a target, rather than a starting point. It should no longer be a question of what communities a group works *with*, which often means in practice what communities a group works *on*, for implicit in the notion of 'working with' communities is very often the idea of the community as a blank canvas upon which 'experts' can paint ideologically correct pictures. Instead the question should be concerned with the nature of community that a group is working towards; that is, what community a group is *participating* in bringing into being. And if we adopt this

position it has an immediate and practical effect on community arts work. The work ceases to be an imagined microcosm of a larger, and always absent, whole, and becomes what it really is: a group of people engaged in a process of collective creativity. In other words, when a community artist is working with six people, they should no longer be seen as 'representatives of some notional group, but viewed as six people worth working with in their own right.

When we take on board the state's static definition of community, we inevitably take on board with it a pessimism and negativity which stems from the erroneous belief that, in some strange way, we are never quorate. Funding agencies regularly ask whether groups are 'representative' of people in their area, or of women, or of black people; which serves to raise the status of all those people with whom groups are *not* working above that of the people with whom groups *are* working. This spurious notion of representativeness reduces the people with whom we work to simplistic caricatures of the statistical group from which they are supposedly drawn and turns them into demographical archetypes of little or no substance. This in turn hinders the genuine possibilities of community arts work; the possibility of participating in groups which are confident and competent, and whose competence and confidence are the starting points for action.

The static definition of community, with its implication that anything less than a mass meeting is inquorate, and incapable of deciding anything 'on behalf of the community', can easily lead us to believe that we are engaged in some kind of heroic struggle to create a proletarian art, which would serve to bring this mythical mass meeting into being. This struggle is absurd in theory and impossible in practice. All we can ever hope to do is create art with some proletarians, and moreover that is all we should want to do. The notion of a 'proletarian art', like the notion of a static 'community', is a chimera, a delusion founded on the belief that we need to mirror the dominant culture rather than supercede it. The forms of the dominant culture are one of its defining characteristics, and the idea of a single, centralised culture is one of its forms. These forms cannot be replaced by a different brand, in the way that washing powders or toothpastes can be replaced. They must be superceded by something fundamentally different in kind. To undertake this task, we must have a clear understanding of what we mean when we talk about 'producing art'.

Chapter Eight

Art

If the community arts movement has been unclear about the nature of *community*, and the way in which community relates to the agencies and processes of the state, then it has been equally unclear about the nature of *art*, and the way in which it is defined in our society and the methods by which it is produced and distributed. Instead, community artists have often dodged the issues by claiming that such a discussion would be diversionary, or unhelpfully obtuse, and they have thus been forced, by default, to rely on a loose set of entirely unargued 'common sense' definitions of what art is.

This confusion has had a number of calamitous consequences, not least of which has been a prevalent tendency to concentrate on the mechanical techniques of the various art forms, to the exclusion of any consideration of the necessary mental techniques of thought, planning, style and aesthetic decision which govern them; or the wider social forces which shape and direct those mental techniques. This has occurred because of the community arts movement's inability to deal with questions of style, due to the movement's lack of any common theoretical understanding; and through the resulting (and erroneous) assumption that the material means of artistic production are somehow neutral, and therefore capable of being used without any questions being asked.

At its most simplistic, this has resulted in the sort of community printshop where 'clients' are shown the minutiae of screen-printing (how to wash the screen, how to apply green film, how to use a light box) as a neutralised technical subject, and then given no assistance at all in the process of designing the poster they are going to print. In a confused bid to avoid imposing style or visual language on the users, this type of practice actually undermines the aims and purposes of those people wanting to produce the poster. For example, if the poster is for an AGM or a fund-raising dance then it will have served its purpose if it contributes to a well-attended AGM or dance, and will have failed if nobody turns up. The fact that this purpose may be impeded more by bad design than by bad reproduction is often never discussed, even if it is understood. Instead there is contented talk about the way in which learning to use a silkscreen 'demystifies' the process of printing; a benefit which is at best a secondary

consideration for most of the users.

In refusing to develop a theoretical framework, it becomes easy to imagine that a full and effective knowledge of visual language will spring whole from any group of people as soon as their blindfolds have been removed; and to imagine that their blindfolds can be removed by showing them the mechanics of a silkscreen or a 35mm darkroom. To believe this is to fall into the very 'naive romanticism' which Lord Gibson accused politically motivated community artists of exhibiting. Ironically, however, the way out of this dilemma is not, as he would have it, less theory and more 'common sense', but the reverse: a well argued theoretical framework which provides a basis for questioning lazy 'common sense' assumptions.

Art is an ideological construction; a generalisation which has a complex history through which its meaning has both shifted and narrowed. In its current usage its chief purpose is to bestow an apparently inherent value onto certain activities and the products resulting from these activities, while witholding this value from certain other similar activities. In this respect the term 'art' functions as one of a series of categories whose purpose is to assist in the construction and maintenance of a hierarchy of values which, having been constructed, can be made to appear as both natural and inevitable. Thus there are activities which may be interesting and rewarding in their own right, and which may be pursued as hobbies, leisure activities or even careers, but which will never, no matter what standard they reach, be accorded the status of art. The process by which this happens is profoundly political: it is not in any sense a consequence of impersonal market forces, nor is it the unfortunate outcome of a series of historical accidents. It is the result of some groups being more powerful than others; of some groups being in the position to gain access to the levers of power which is denied others.

The process of persuasion, or trickery, through which sculpting in bronze is designated a living art form and model aeroplane making is relegated to the status of an adolescent hobby, is almost entirely concerned with an ability to engage the interest and approval of those agencies which have achieved a *de facto* power to license activities, or classes of objects, as art; and almost nothing at all to do with any specific 'value' in the activity itself. A visit to a large model railway exhibition will readily confirm this, for many of the more ambitious layouts are self-evidently the result of vision, planning, craftsmanship and tenacity. They could legitimately be described as an evocative, and peculiarly British, form of social realist sculpture, and indeed, if they had happened to be built by an accredited 'artist' as part of a private and 'artistic' obsession, and if they had happened to be located in an accredited gallery, that is how they would be described.

As it is they are seen, if they are seen at all, as a kind of wilful infantilism.

What we refer to as 'the arts' amounts to a selection of activities within a much wider area, which we could refer to as *pleasure*. Moreover, the arts are a class specific subdivision of pleasure, since they coincide with the habits of enjoyment of a metropolitan ruling class. Historically, they are the descendants of the *court arts*, through the patronage of which the royalty and nobility amused themselves and demonstrated their prestige and power. The claim these 'arts' make to moral or intellectual superiority comes from their lineage, and from the powerful positions of those advancing these claims on their behalf, and not from any inherent qualities that they possess.[7]

Ed Berman has asserted that the tradition initiated by Lord Keynes in CEMA (and later in the Arts Council of Great Britain) of funding a narrow spectrum of cultural activities, which produce pleasure for the participants and possibly for the spectators, while ignoring the rest of the population, is 'an upper class, cultural imperialist trick'. He argues that 'the reason we give money to opera and not to, say, tiddleywinks or model aeroplane making is that a small group of people have, over the years, been able to persuade, or trick, an even smaller number of people who have their hands on the levers that an eighteenth century folk art is somehow normal or normative for twentieth century British society. That smaller group of people, through a host of agencies of governmental processes have then also managed to persuade, or trick, the whole of the rest of society into believing that this folk art is normal for our society and deserving of subsidy, whereas it really is not.'[8] This process of 'persuasion' has not just involved the extolling of the operatic virtues, and their inflation into an alleged cornerstone of civilisation, but a powerful and systematic downgrading of other activities, which have been shunted into categories which are treated as though they were automatically, and self-evidently, of a lower order. To be near the top of the category *country and western* is still to be ranked as less 'serious', less worthy, than almost anything in the category *operatic aria* in the eyes of those controlling the institutions that together determine the dominant cultural agenda; the group of activities that we mean when we talk, as Sir Roy Shaw has, about 'serious art'.

This is not a new argument. As long ago as 1843 Jeremy Bentham argued that 'prejudice apart, the game of push-pin is of equal value with the arts and science of music and poetry. If the game of push-pin furnish more pleasure, it is more valuable than either.'[9] Bentham was arguing here for a strictly utilitarian form of populism in which,

in modern terms, *The Sun* would have to be seen as a better newspaper than *The Times* because more people buy it. He was arguing that there are *no* possible criteria in matters of judgement and value, other than simple numerical criteria. What I am arguing (and what, I believe, Ed Berman is arguing) is related to Bentham's argument, but it is not the same, and it is more complex in both its premises and conclusions.

I am arguing that what we refer to as *art* is but one facet of a range of social practices in which communities engage, and through which they derive meaning and pleasure; and that we must understand this, and understand its consequences, before we can begin to categorise one thing as better artistically than another. We cannot do this by simply referring to the works of art, or the art practices, as though they contained some innate qualities missing from push-pin. Instead, in trying to gauge the value of a work of art, we must make our judgement specific rather than generalised, material rather than abstracted. Rather than trying to deduce a single universal value from a work of art, we must be prepared for an infinite series of different specific values in answer to the question: to whom is this art of value and for what purposes is it valued? From this perspective we can see how opera relates to the wider social practices of one social group while leaving other groups untouched. We can also see that, for another social group, the same is true of country and western music; and that this difference provides no basis whatsoever for ranking either the activities, or the groups who participate in them, in some wider cultural hierarchy.

As with the term *community*, we must use the term *art* in a dynamic way, recognising that if it describes anything useful at all it is a set of social relationships, and the social practices that result from them. Such a way of looking at art is suggested by Raymond Williams:

'The distinction between art and non-art, or between aesthetic and other intentions and responses, as well as those more flexible distinctions by which elements of a process, or intentions and responses, are seen, in real cases, as predominant or subordinate, can ... be seen as they historically are: as variable social forms within which the relevant practices are perceived and organised. Thus the distinctions are not eternal varities, or supra-historical categories, but actual elements of social organisation ...'

The term 'art', then, does not describe a set of activities, but a framework within which certain activities are placed, and the distinctions which are maintained between 'art and non-art' are part

of the dominant structures of our 'social organisation'.[10]

For our purposes, art can best be seen as a term used to describe a network of inter-related activities, of cultural practices, and not as a label to be wielded in a limiting or excluding way. The more usual use of the term, in which it is contrasted with an existing category of 'non-art', can only amount, at best, to a self-conscious claim to be part of a particular heritage. This is a claim which, in the end, amounts to an attempt to legitimise a pleasure through analogy; through the assertion that a pleasure is important because it resembles a previous activity which is now considered to have been important. Thus drab, serialist composers today claim their 'art' to be worthy of attention because they assert that it is the direct descendant of Beethoven, Mahler and Schoenberg, and attack the public for remaining resolutely uninterested in it, for refusing to 'make the effort'.

If we see art as a similar kind of term to community, we can see that it too describes a goal to be attained, not an abstraction which must be seized or captured. This goal differs from the goal of community, though, in that it cannot *itself* be pursued. It is a generalised *effect* which will arise from within specific work practices, which will themselves necessarily take particular material forms. These practices might be photography, or mural painting or printing or cookery or writing or drama or gardening. We will be too self-conscious if we habitually claim that we are doing these things *as artists*, even though the creation of an art may be a part of our goal. We are, in fact, doing these things as photographers, muralists, printers, cooks, writers, actors or directors, and gardeners. These are the roles which, in one way or another, we actually occupy; and our eagerness to designate ourselves as 'artists' or 'community artists' is often a way of demystifying our actual practice to the disadvantage of the people with whom we work.

This can be easily demonstrated. If I announce myself as a community artist, the people to whom I am talking are likely to have no way of deciding what their expectations of my skills should be, since the title does not relate directly to any specific skills or practice. If, on the other hand, I announce myself as a photographer, the people to whom I am talking *will* have a set of criteria which they can adopt in order to form an opinion of my skills. They will have opinions about photographs, they will be able to ask to see some photographs that I have taken previously, and they will be able to relate the two in a way which will enable them to decide how seriously to take what I tell them. They might ask questions that they feel a photographer should be able to answer, or they might watch me load a camera to see how competent I am. In announcing myself as a community artist I run the

risk of revealing so little about myself, in terms which people can understand, that I can never be challenged by the group with whom I am working. Where this occurs I will forever be the externally validated teacher imposing my will on the class, and never a participant in a democratic group.

If we can see, then, that *community* and *art* are both descriptions of processes which are, for our purposes, aims and goals, then we can see that the term *community artist*, while being a convenient label to use in some circumstances (most of which are concerned with funding), does not, in fact, describe *what* we do, but only *why* we do it. We can see, too, that it is entirely possible to pursue the goal of creating an art, or of creating a community art, without the need to designate some people as 'artists', with the implicit assumption that there is a larger group of people who are not artists. The term 'art' must therefore be removed, in our practice, from any imagined relationship with a polar opposite called 'non-art'; and recognised instead as a different kind of category altogether. It is a category which cannot be approached like a kidnapped heirloom, and somehow seized back, but must instead be analysed and acted upon dynamically. If we do this we can begin to imagine a community arts movement without any 'artists', but with a variable set of producers and authors, working in partnership. We can begin, then, to look at the processes of creativity and authorship which are supposed to fuel the production of art, and in which, in one way or another, we all participate.

Chapter Nine

Creativity and authorship

When *Sir Alfred de Musset* claimed that 'great artists have no country' he was providing a succint summary of the Romantic credo: the artist was *different* from ordinary people, visited by a genius which stood outside geography and outside history, and which enslaved him. The creativity which so troubled the artist was simply not available to most people, and could not be bound by any laws whether social, economic or legal. The artist, it was claimed, was detached from all norms.

This view of artistic production, which superceded a view based around motions of religion devotion, and which still lives on in contemporary 'fine' arts, did not arise in a random or arbitrary way, but reflected changes and developments in the world of politics and economics. Yet there is no evidence to support this view of artistic genius, and nor is there any evidence to show that there is a discontinuity between the acts of a putative genius and the acts of the rest of us. On the other hand, it is not at all difficult to demonstrate that, in an admittedly complex variety of ways, all creativity is at root a social and not an individual act. The determined effort to 'sell' the idea that creativity is a rare, and uncontrollable, individual quality has much more to do with 'selling', and the profits to be derived from it, by those who can control what is for sale, than with any inherent truth the idea itself might possess.

Before the Renaissance period, the production of art was the province of the guilds, and was organised along communal lines. Craftsmen employed assistants and pupils as a matter of course, for it was not deemed important to lay a personal claim to every brush stroke. Indeed, it would have seemed an absurd and boastful posturing to have done so. This was because the art that was being produced was not really 'art' in the modern sense at all. Its production served a social purpose; it decorated walls, it commemorated saints, it spoke of the glories of Heaven and the power of God, and it idealised the glory and the power of the nobility. It was not concerned, as modern art usually is, with glorifying its own existence, and the genius of its creator.

The production of popular culture today is similarly collaborative, whether it occurs in the field of film, music, magazines, comics or computer games. One or more craftspeople habitually employ the

services of many assistants and skilled specialists. The Frescoes on the walls of the Arena Chapel in Padua, then, may be said to be 'by' Giotto in the same sense that *Rio Bravo* may be said to be 'by' John Ford. Indeed, wherever we look, the allegedly solitary nature of the creative act melts in front of our gaze. Nobody could deny that any film which is conventionally referred to as a work by John Ford is, in fact, the result of the collaborative efforts of many dozens of people, whose efforts, if done differently, would have produced a noticeably different film; as well as many more people whose effect on the final product was less direct and hence, to an audience, less noticeable.

Similarly, nobody would deny that an orchestra is dependent on all of its members working together to a mutually agreed purpose, and that any section of an orchestra which played badly would seriously affect the way that the entire orchestra was judged by an audience. This would occur regardless of the 'genius' of the composer, the conductor or the soloists. But although this is widely accepted to be true, it is often argued that these methods of cultural production are somehow atypical or exceptional; or that, at the very least, there remains a residue of artistic practices which are necessarily individual. Thus the collaborative aspects of writing, of painting or photography are dismissed, despite the many demonstrations of their importance by both literary critics and sociologists.

The idea that artistic creativity, in its most 'serious' forms, is necessarily a solitary business, has been used with various degrees of sophistication to decry the claims of community artists that they are creating work collectively. The response of community artists to this kind of attack has often been a defensive one, an attempt to find the quickest way out of trouble rather than an attempt at actually meeting the challenge. This has led us to undervalue the possibilities and potency of our own working methods, and to keep quiet about the very things which are our real strengths. Since I believe that collective creativity forms the core of community arts practice, and since I believe that it has political potency, I shall attempt to demonstrate its existence as a general, and normal, feature of cultural production. To this end, I wish to look in some detail at the process of producing a photograph, an activity which is usually claimed, by those wishing to deny the feasibility of collective creativity, as a necessarily solitary act. I believe that it is possible to show that photographic practice is neither solitary nor individual, and that it is possible to draw more general conclusions from this demonstration.[11] These wider conclusions are important in any attempt to construct a political framework for community arts.

Most contemporary photographers and critics take it as axiomatic that photographs are, in some more or less complex way, faithful

visual records of 'reality', made possible through a particularly clever technology which has been steadily developed over the past 150 years. They also claim that, in all but the most exceptional of circumstances, the photographer is the sole author of the photograph. Indeed, in terms of the 'art of photography' this notion is crucial, for it is held to be the photographers' individual visions, and their idiosyncratic geniuses, which enable them to capture reality on a piece of paper in a way that is not possible for the millions of amateurs who send their holiday snaps to be processed every summer. This is as true on the political left as it is elsewhere, and as true among community arists in general as it is elsewhere on the left. Only the names of the heroes are changed: from Henri Cartier-Bresson to Don McCullin, from Helmut Newton to Victor Burgin. Photography is seen as a translation of a three-dimensional reality into a static two-dimensional image. It is claimed, in this respect, that there is an important difference between the studio photographer, who constructs a kind of reality which is then recorded by the camera, and the documentary photographer who records a reality which is, in important ways, beyond her or his control.

Because of these beliefs, any discussion of photography can easily become reduced to a discussion about the reasons underlying the selection of an image, about where its borders have been drawn, and about the size and scope of the photographic framing. The photographer's role is seen as one of choosing the area of reality to record, choosing the angle from which to view it, and of highlighting or focussing upon certain constituent parts within that reality. The photographer is considered to be an author with a particular way of seeing reality, and photographic criticism is constructed as a commentary on those ways of seeing.

Pinhole photography, however, which has been used within a variety of community arts practices, raises serious questions about the authorship claimed by photographers, and about the nature of the reality which they are alleged to record.[12] The recording process in pinhole photography takes far longer than the recording process used by 'standard' cameras, due to the fact that pinhole cameras have no lens to intensify the available light. They usually use photographic paper as a negative material which, being considerably less sensitive to light than film, results in exposure times ranging from a few seconds to many minutes. In many respects, then, pinhole cameras are similar in their constraints and limitations to the primitive plate cameras which preceded George Eastman's development of the Kodak camera.

'Standard' cameras, on the other hand, are designed to operate between speeds of approximately one second and one thousandth of a

second, for reasons of technical simplicity. Most photographic equipment is designed to be operated within this time zone, which has become the unquestioned operational time zone of modern photography. This zone is no more the 'natural' zone of operations of photography than any other time zone. It is a range which has been selected by the manufacturers of photographic equipment, for a series of interlocking reasons to do with the development of the relevant technical knowledge and the need to produce equipment profitably and in large quantities. Moreover, the decision to locate popular photographic technology within this time range has a series of determining consequences on the photographs that can be produced, and over which authorship is claimed.

Since few human movements are faster than one hundredth of a second, modern photographic portraits tend to be sharp, unlike old portraits which often have a blurred softness to them caused by far longer exposure times required. This fuzziness is not caused by the subject being out of focus but, as Paul Orlich has pointed out, is the result of an overlaying of many insubstantial images formed by the slight and involuntary movements of the subject while the photograph was being taken. Movements are recorded by pinhole camera, as they are by 'slow' plate cameras, that occur too slowly to be captured by a modern camera in ordinary use, while conversely they are unable to produce clear images of the much quicker movements that are 'standard' photography's stock in trade.

Portraits taken with a pinhole camera, or a 'slow' plate camera, are not a series of even blurrings across the whole subject. The images are often composed of different degrees of blurring in the head, shoulders and hands, with clearly defined legs, feet and torso. The background may contain blurred objects such as the branches of trees, but static objects such as buildings and hills will remain sharp throughout the picture. Pinhole photographs, then, are a record of both movement and lack of movement throughout the image, and while this is in principle true of all photographs, pinhole cameras use exposure durations which enable the subject to take an active part in the construction of their own image, since both involuntary and voluntary movements of the body are able to be recorded *as movements*, and thus form a constituent part of the fictive drama that the image depicts.

In this form of photography, using pinhole or plate cameras, the 'subject' is therefore able to participate in the authorship of their own image. The 'photographer' is still able to make all the usual selections which allegedly mark their particular way of seeing, but another channel of authorship is opened which the speed of 'standard' photography normally precludes. There is in fact the possibility of joint authorship by the 'subject' and 'photographer', who between

themselves can share the roles of actor, director and camera-operator. Where the image is a portrait, and where it is constructed over considerable time, it can scarcely avoid being a collaborative venture in which, for example, the photographer modifies the initial suggestion in the light of the subject's efforts, the subject counters with another suggestion, and so on.

In thinking about this process, and the way in which it works to produce an image which, whatever else it may be, is neither arbitrary nor random, it becomes possible to see how *all* photographs are jointly authored, and how the notion of the 'individual photographer' is as much a myth as the idea that the technical equipment used in photography is neutral rather than constraining, value-free rather than determining. 'Standard' photographs taken at speeds faster than a thirtieth of a second are jointly authored since the authorship of these photographs is, in the first instance, shared between the photographer and a mathematically probabilistic form of chance. Nobody can think at a five hundredth or a thousandth of a second, or at least nobody can transmit data from eye to brain to hand at that speed, with any guarantee of accuracy. This applies as much to an experienced and accomplished photographer like Cartier-Bresson as it does to the 'ordinary' person taking their holiday snaps.

Cartier-Bresson, however, can do two things to increase his chances of capturing 'the decisive moment'. He can take a large number of photographs at approximately the right instant, and he can use his experience to try to second-guess the instant at which he should release the shutter. Both of these strategies rely on the assistance of chance, for without that assistance there might be nothing at all on the roll of film striking enough to be called a Cartier-Bresson photograph. This co-authorship is hidden from view, although it is always present. It is hidden partly by the weight of photographic critical tradition, which confuses and elides two distinct (and in many ways, opposed) photographic practices. It is also hidden from view by the critical language that has developed out of this tradition, and which makes no distinction between *camera-operator* and *post facto editor*, and has created no language through which this distinction can be readily elaborated.

When Cartier-Bresson, or any other photographer taking 'candid' photographs (from Don McCullin to a provincial newspaper sports photographer), produces a set of prints for public consumption, he produces them from a much larger set of negatives, most of which will never be seen outside the darkroom. In his role as camera-operator he will have taken a large number of images at approximately the right instant, and it is from these that he will select the small number which he judges to be representative of the 'decisive moment'. This process is separate from the action of producing the images, and is a subsequent

act of editing, in which the parameters are clearly determined by the images that have alreay been captured on film. This editing is usually, but not necessarily, performed by the person who acted as the original camera-operator; and the elision of these two roles serves to further disguise the joint authorship of all photographs.

In the role of *post facto* editor, the 'photographer' makes a range of selective judgements which reveal, in a different way and at a different level, the essentially collaborative nature of authorship. The process by which the photographer's selections are made is informed by the personal history of the photographer (by the steady accumulation of experience and knowledge), but also by the social history of the group and class to which the photographer belongs, and by the related social history of photographic practices, and by the use to which the photo-graph will be put. The photographer does not make selections concerning which negative to print, and which print to exhibit, in a vacuum: they are made as part of, and in response to, prevailing aesthetic codes and conventions; the construction of which is nec-essarily both collaborative and social, and the mutation of which is a part of the process of history. It is possible, then, to discover a form of co-authorship residing in photographic practices, at both the technical level and the ideological level. This is crucial to the development of the methodology of community artists, for it relates directly to one of the major projects of the community arts movement: the constructuon and sustenance of processes of collective creativity.

This aim has been frequently criticised for being either impossibly naive, or naively impossible. It can now be seen to be neither. Creativity and authorship are always, at one level or another, social acts and acts of collaboration; and where that collaboration goes undetected, as it does in the production of most photographs, it remains free to exert influences which, precisely because they *are* undetected, will be determining. Invisible influences can easily come to seem 'natural limitations' which are both inevitable and ideologically neutral. In fact these influences are often the very targets at which community artists should be aiming, since it is within these apparently neutral areas that the ideology of passive, and intensive, consumption is maintained and developed. Although the presence of limitations of some sort is inevitable, the specific nature of those limitations is not. The limitations which shape and direct passive consumption have been created, to serve the purposes of one group, and they can be opposed and superceded, so they no longer serve that group.

The idea of 'individual' creativity, removed from social influences and springing whole from some secret internal landscape, is a deception. It is advanced at the expense of social co-authorship

because, crudely speaking, co-authorship is bad for business. The mysterious genius which is alleged to lie behind 'individual' creativity has twin advantages. Firstly it creates what are, by definition, scarce resources, which can be bought and sold for profit. The notion of genius effectively prevents the intellectual market place being flooded with cheap goods. Secondly, the idea of rare genius creates, in the minds of those who have not been told they have it, a feeling of inferiority. This feeling of lacking something makes them willing and eager to consume the products of the genius of others, in whatever packages it is sold. This is neither coincidental nor wholly unplanned. It is just one example of the way that the high-intensity market operates within an advanced capitalism.

Chapter Ten

The high-intensity market

Few, if any, would deny that the dominant economics in this society is a form of advanced capitalism which interacts strongly, and in many ways, with other agencies such as the state. Dissent would only arise over whether or not this form of capitalism is a good thing. Some of those who would defend it would do so by the simple (and simple-minded) proposition that it was 'natural'; an argument which assumes implicitly that the laws of economics reside, like the law of gravity, outside society, and outside the possibility of human control.

Others would defend it by admitting from the outset that capitalism was a human construction, and by accepting that, in its early stages, it was accomplished at the cost of widespread human misery and degradation. They would argue that this stage has been passed, and that capitalism now works to everybody's advantage. This argument gains a certain power from the partial truth it undoubtedly contains in that, from some points of view, the poor today are not as badly off as the poor of 150 years ago. They do not, as a class, face chronic malnutrition, cholera, typhoid and the like. They do, however, suffer from a grinding poverty which is no less keenly felt, and no less real, for being relative. If anything the position of the poor today is worse, rather than better, for being the more completely constrained.

The advanced form of capitalism that powers our economy is dependent for its continued existence on the promise of perpetual expansion, in the form of a continued increase in both productivity (and hence output), and in the extent of the markets which will absorb that increased productivity. This perpetual expansion has been achieved by meeting existing demands while simultaneously engineering the stimulation of new demands. Consumer goods have existed for many years in sufficient quantities and in a sufficient range to more than satisfy all the needs that somebody living in the middle of the nineteenth century could imagine; but this is no longer their point, if indeed it ever was. Goods are no longer sold on the basis that they satisfy a known and voiced human need, but instead demands are developed through 'research' and through marketing in order that commodities may be produced to meet them. Nor is this accidental, for the dedication to expansion is a vital part of the driving motor of capitalism, being inherent in the very notion of production for the sake of profit.

If the purpose of production is conceived as the production of surplus value, and the actual goods produced are seen only as one stage in the production of that surplus value, then there can be no such thing as *sufficient* production of any commodity, since there is no such thing as sufficient surplus value. Wealth, as a value in its own right, has no logical upper limits. It has only socially determined lower limits, below which live those of no status and even less credit-worthiness.

This redefinition of our needs through 'research' and marketing is achieved by the creation and development of what William Leiss has termed a *high-intensity market*, in which needs are broken down into ever-smaller units to be satisfied by an ever-increasing, and apparently unconnected, array of products.[13] Thus, for example, the desire to avoid giving off offensive odours is redefined as a positive, and normal, desire to achieve 'personal hygiene', and is pictured as a continuous, and inevitable, struggle in which only the deliberately anti-social would refuse to participate. This struggle is then broken down into smaller and smaller subsections (underarm, oral, vaginal, feet etc), each of which are treated as separate marketing zones, within each of which the consumer can be educated to make choices (roll-on or stick, fragrant or natural?), and within each of which separate innovations are possible.

This process, through which our needs are refined so that they match the outputs of a profitable production process, and then sold back to us, is central to the functioning of the high-intensity market. It can be seen operating in all those areas of production (material or ideological) which have been industrialised. It can be seen in photography, for example, where in 1887 George Eastman founded the Kodak Company for the express purpose of marketing a profitable, industrialised equivalent to existing photographic practices.

Eastman wrote in the primer to one of the early Kodak cameras that 'the principle of the Kodak system is the separation of work that any person whomsoever can do in making a photograph, from the work that only an expert can do . . . We furnish anybody, man, woman, or child, who has sufficient intelligence to point a box straight and press the button . . . with an instrument which altogether removes from the practice of photography, the necessity for exceptional faculty, or in fact, any special knowledge of the art. It can be employed without any preliminary study, without a dark-room and without chemicals.' What Eastman was, in fact, selling was a camera which was loaded in the factory with a roll of film and which only required to be pointed at an object and the shutter released. Once the whole film had been exposed the complete camera was posted to the factory, where it was

reloaded and sent back to the customer, with a set of photographs from the previous film. In doing this Eastman developed a new market of photographic consumers, whom he dissuaded from learning about the processes of photographic production ('the work that only an expert can do.'), but persuaded to take an increasing amount of photographs. Thus, in the guise of a mere technical improvement, an entirely new practice was begun.

The operation of the high-intensity market is not restricted to the field of culture, however, nor to the marketing of 'luxury goods' like cameras and deodorants. It operates *throughout* advanced capitalism, in the service of the dominant groups and class in society. We can see the same process at work in the industrialisation of baking, and the creation of the industrialised British loaf: the uniform, standardised white bread which most people buy and eat. Until the beginning of the twentieth century, white bread was a delicacy reserved for the very wealthy, since the only way that pure white flour could be produced was by sieving stone ground flour, by hand, through silk. The stone grinders that millers used were incapable, on their own, of producing flour which was paler than light brown. Even producing this sort of flour required care and expertise. The steel roller mills which began production in about 1880 changed that, for they were not suited to the production of whole wheat flour. White bread was, therefore, sold to the poor as 'a novelty, and at least four times as much was eaten, for it was a major source of protein'.[14]

By the 1920s the demand for bread had fallen by a quarter, as people were able, in general, to afford a more varied diet. Hannah Wright has described how 'the mills began to go bankrupt, and the Millers' Mutual Association was formed, partly to buy their machinery and thus prevent new competition from entering the market. At this time, most bakers were craftsmen, baking for one or two shops. The Co-op was the only big baker with 20% of the market.' In 1932 Garfield Weston arrived in Britain, having made a fortune in Canadian wheat, and began buying up bakery businesses, which he supplied with his Canadian flour.

During World War Two, Weston was unable to get Canadian wheat, and switched to buying from Rank and Spillers. When, after the War, he reverted to Canadian wheat, both Rank and Spillers started buying bakeries themselves, in order to guarantee their own markets. Later Weston, whose businesses were now under the Associated British Foods umbrella, began buying retail shops for his bakeries to supply, as did Rank, which became RHM. By 1976, when the Monopolies Commission investigated the baking industry, there were only 39 independent millers in Britain, as opposed to over 2,000 in 1935. ABF, RHM and Spillers owned 80% of the milling industry,

and controlled 61% of the bread market.

During the 40-odd years between Garfield Weston's arrival in Britain and the report of the Monopolies Commission, the British loaf had undergone a radical change. It was no longer characterised by its whiteness, but rather by its increased chemical content; all of which was there for the producers' benefit, and none of which benefited the consumer. It was aerated, dyed and treated chemically so that, in terms of shelf-life, it was practically immortal. Yet people were persuaded that what they were eating was still the same sort of bread that they had always eaten, in a more 'modern' package. Thus, in the guise of a succession of merely technical improvements, a new diet was begun.

The development of industrialised analogues to existing practices of photography and bakery is, at one level, the result of opportunistic initiatives by entrepeneurs. Yet at another level, these developments are examples of a far wider pattern of initiatives. These initiatives, in all their complex inter-relationships, form the high-intensity market. This arose partly as an unplanned response to the pressures of capitalism, with its insatiable demand for new markets, and its increasing desire that these new markets should be so ordered that they could be systematically exploited. It also arose, however, as a planned strategy, organised by certain powerful groups. This strategy was the ideological counterpoint to the technical and organisational innovations of people like Eastman and Weston, and was concerned with the industrialisation of consciousness: the production of the values, goals and taboos which best fit the needs of capitalist production. This strategy firmly links culture and economics, and its effects can be felt through the network of determining agencies. It affects the terms within which political, and social, actions and debates take place, and it makes cultural activism a necessary part of political action.

Radical monopoly

Community artists need to be aware of the state, and the ways in which it functions, although community arts practice is not usually concerned with the state in its entirety. Rather it is concerned with the state as it affects specific groups of people; and particularly with the way it affects them in the areas of community and cultural production. To understand the way that the state interacts with cultural production, and the results of that interaction for the people with whom we work, we must examine the ideology of consumerism, and the ways in which this ideology has been organised and given force.

In *Captains of Consciousness: advertising and the social roots of the consumer culture*, Stuart Ewen suggests that the ideology of consumerism was deliberately planned in the USA in the 1920s, led by business spokesmen such as Edward Filene from Boston. By quoting from the speeches of Filene and others, and producing evidence from contemporary trade journals and books, Ewen presents a picture of the following themes which were, he alleges, explicitly discussed and planned for.

Demands for workers' control in industry, which was characterised as bolshevism, would be weakened by a deliberately increased access to consumer goods. To this end, participation would be redefined as the right to exercise consumer choice, which would be propagated as the new and appropriate form of democracy for a 'modern' society. Non-English ethnic minorities would be 'Americanised', and dissuaded from maintaining their own cultural interests; and a uniform national taste would be cultivated through an increased use of widely-disseminated advertising messages. The spheres of production and consumption would be strictly separated so that, for example, advertisements for consumer goods would never depict realistic workplaces.

The family would be opened up to social pressures by the use of 'home economics' courses in schools, which would extol the virtues of the latest consumer durables, and would train girls to their use. Male and female roles would be separated, with attention given to the presentation of women as sexual objects. The realm of personal consumption would be transformed, and individuals (especially women) would be pressurised into buying manufactured items, such

as food and clothing, which in previous eras they would have made at home.

The depression, and the Second World War, delayed the implementation of these ideas, and they were not finally implemented until after 1946. For 20 years before that, however, a powerful group of American manufacturers and businessmen were being encouraged to reorientate themselves along precisely these lines. People like Edward Filene recognised that, in order to continue expanding capitalism would have to move beyond the production of goods to the production of consumers trained to need those goods.

The breakdown of human needs into smaller and smaller fragments is not restricted to those areas of life where imputed needs are met directly from within the market-place. It has become a *modus operandi* for advanced capitalism, for it provides an efficient means of organising the large-scale provision of goods and services profitably, and with as little risk as possible. It finds its parallel within the state, in the reduction of human beings from consenting citizens to dependent consumers. The habit of dependent consumption is sustained, and reinforced, by the activities of the state, which requires us to redefine our needs in such a way that they can best be met by an increased consumption of quantified professional services.

The development of the National Health Service provides an example of this process in operation. It was introduced as the result of an Act of Parliament, proposed by Albert Beveridge, and passed into law in 1946. The aim of this Act was to allow everybody to attain the level of health which had only been available previously for the very wealthy. The aim, in effect, was to introduce universal suffrage in health care. This plan was founded on two theoretical assumptions: that at any one time there was only a certain amount of sickness in society, and that this level of morbidity could be reduced rapidly by universal free treatment. Beveridge believed that much sickness was the result of neglect due to poverty, and he was convinced that a free service would soon overcome the illnesses of deprivation.[15] The general level of health would therefore rise, with a corresponding decrease in the demands placed on the health service. He envisaged the health service gradually diminishing in size as the overall level of health rose, until all that remained was a low-level service providing the small amount of treatment that would remain necessary.

This did not happen, of course. Instead the NHS grew as an arm of the centralised state. It failed almost completely as an agent of a positive, healthy way of living, and became a mere dispenser of medicines and potions, the secrets of which it guarded jealously. The number of home births, for example, fell consistently, until they came to be seen almost as acts of dissidence. Childbirth became one more

illness which needed to be 'treated' by the intervention of trained professionals; and as the power of the health service grew, so its treatments assumed an air of compulsion.

It would be possible to imagine a health service doing what Beveridge envisaged. It would develop a range of courses, and low-cost equipment, designed to facilitate childbirth at home, with the minimum of outside interference, for all those who wanted it. It would develop a range of training courses, and readily available remedies, which would allow citizens to cope with their minor complaints, and the minor complaints of their friends and family, in as autonomous a manner as they desired. The health service has not done these things, however, for it has never been the people's friend in the way that Beveridge intended. Instead it has become the centralised supplier of products, and externally controlled services, to the rest of us, in our role as medical consumers.

It has been left to medical activists, and participants in fringe medicines, operating in areas outside the mainstream of contemporary medicine, to argue the virtues of healthy living, and the vices of the industrialised, and processed, diet that we are sold. The health services have trailed limply behind, mumbling warnings of the gentlest sort, just loudly enough to fend off charges that they are doing nothing, but hardly loud enough to dent anybody's profits. The DHSS, for example, in its booklet *Eating For Health*, says that 'sweet food may help a child develop a sweet tooth, and perhaps eventually to lose his (sic) teeth due to dental caries'. This is, perhaps, as far as you can go to underestimate the evidence without actually lying.

The state-organised education system has undergone a similar, and more fully documented transformation, albeit over a much longer period. Education is no longer concerned to be an extension and complement to the voluntary acquisition of knowledge through learning. In its present form, it is about the compulsory absorption of information through an externally planned programme of observation and imitation. Teaching is carried out according to predetermined criteria, and with the attainment of specific, universalised standards as its object. Any attempt to do otherwise is treated as a dangerous attempt to lead children astray, and is either persecuted or demeaned. AS Neill, for example, was written off as an eccentric, so that Summerhill, the democratically organised school which he founded and ran for 40 years, and which was the predessessor of the 'free school' movement, could be regarded as one man's folly; an example of eccentricity which contained no lessons of more general significance.[16]

Education has become a pre-packaged commodity which is force-

fed to young consumers through a nationalised system of distribution, and whose success is measured by the degree to which the young consumers absorb the package. Its effect is to educate the consumers in the art of passive consumption. Motivation resides not in the learner, but in the educationalist, whose professional responsibility it is to see that the rate of consumption is maintained at an approved level. Internally motivated autonomy has been sacrificed for externally motivated dependency; just as, in the interests of profitability, the training of consumers has taken precedence over the education of citizens.

I am not intending to suggest in these examples that medical patients feel no pain, nor that some children do not enjoy their schooling; nor, indeed, that doctors and teachers are heartless robots programmed to carry out certain functions. What I am saying is that, regardless of the motivations and abilities of individuals working within them, at an institutional level the health service and the education system are agencies of the centralised state, and can be seen to behave as such. Thus doctors, whatever their personal beliefs, are obliged, by interlocking systems of legal rules and social expectations, to license illness, and thus legitimise absence from work, through the issuing of medical certificates. Teachers are similarly obliged to license access to job opportunities and career structures through the issuing of certificates and diplomas. Both medical and educational certificates are issued only after the consumption of goods or professional services, and both serve as licences which permit access to further goods, services and benefits.

The fragmentation of human needs, and the provision of separate goods and services for each fragment, has become the *modus operandi* of an advanced capitalism committed to infinite expansion. Its purpose is to increase the overall amount of goods purchased by each consumer, and to habituate consumers to the idea of equating satisfaction and happiness with the purchase of goods and services. Its effect has been to create that kind of monopoly of expectation which Ivan Illich has termed a *radical monopoly* — within the state, the market-place, communities, organised politics and cultural practice.

Illich has described radical monopoly as 'the dominance of one type of product (or service) rather than the dominance of one brand'. This occurs when 'one industrial production process exercises an exclusive control over the satisfaction of a pressing need, and excludes non-industrial activities from competition'.[17] The example used in *Tools for Conviviality* is the way in which the combustion engine has gained a radical monopoly over movement in Los Angeles. This has happened because the city has been deliberately designed to fit the potential of the automobile, and has, in the process, become unusable

for pedestrians. Everything is simply too far away from everything else for people to be able to walk to work, walk to the shop, or walk to the cinema. The automobile, therefore, has moved from being a luxury item, which enables the occupants to travel further, faster, or in more comfort, to become an essential prerequisite of life in Los Angeles. The poor take the bus, and those who cannot afford the bus fare are completely disenfranchised.

Those who are disenfranchised in this way could be said to be suffering from a peculiarly modernised poverty; an inability to keep up with an accelerating rate of consumption. Peter Townsend has written that, in a society such as ours, 'poverty can be defined objectively and applied consistently only in terms of relative deprivation'. Jeremy Seabrook, however, has pointed out that there is a major problem with the concept of relative deprivation, if it is imagined that it can be applied in a neutral, value-free manner. He argues that, in relative deprivation, 'the concept of poverty is no longer anchored in human need, but becomes an aspect of an economic system; and can therefore never be eliminated'. Poverty has undergone a process of redefinition, and a different poverty has been invented which is tied to consumption within the high-intensity market, and which is capable of being ameliorated only by increased consumption. That process closely parallels the redefinition of photography that George Eastman embarked upon, and which led to the construction of a different photographic practice. Here, as there, the aim is to enlarge the areas of human activity which can be turned into needs, which can then be met through the consumption of industrially produced goods and services.

Illich argues that radical monopolies arise through the convergence of professional self-interest with the underlying motivations of a society organised around a belief in limitless industrialisation, and the resulting centralisation of production and decision-making. Radical monopolies represent a form of social organisation beyond that of simple capitalism, even where they are ostensibly part of a capitalist system; and even where, at one level, they are governed by the need to maximise profitability. By the time a radical monopoly has been established effectively it will have ceased to serve only those demands which have an independent existence, and will have begun to shape the demands that it will claim to service. Asserting that it represents the only feasible solution to a problem, those engaged in constructing a radical monopoly will use it in such a way that it *becomes* the only feasible solution. Consumers are then invited to make choices from the apparent options which are created *within* the radical monopoly. Thus we can see that Garfield Weston began a process which resulted in a cartel of three companies which controlled, directly or indirectly,

almost all the milling, baking and retailing of bread in this country. From this position they were able to establish one particular kind of loaf, based around a particularly profitable manufacturing process, as what people meant when they spoke of bread. They were then able to create the illusion of *more* choice, where in reality there was almost *no* choice, by marketing this same dough in a variety of different shapes, sizes and wrappers. The radical monopoly of the bakery cartel does not lie solely in their domination of the production and distribution of bread; but in the ability, which they derive from this domination, to determine the popular definition of what constitutes bread, which is, of course, the one that suits them best.

The 'solutions' proposed by radical monopolies have one feature in common, no matter in what area they arise: they involve an increasing consumption of goods or services that are produced in large, standardised units. Illich says that 'the establishment of radical monopoly happens when people give up their native ability to do what they can for themselves and for each other in exchange for something "better" that can be done for them only by a major tool'. Thus the many craft bakers, who baked for one or two shops, were replaced by the few factories which each produce 'bread' for thousands of shops.

The process of radical monopoly has supplemented the fragmentation of human needs as the *modus operandi* of the high-intensity market, and it has done so within agencies like the state, and within the various agencies of the state, as well as within the economic market-place. The development of the many 'caring' services, each centrally determined, and each staffed by professionalised workers, fits into this pattern, and community arts could well be included in this picture of the 'caring' services.

Advice centres are one example of a state-created radical monopoly. Through their creation, and through their subsequent funding, the state has legitimised one particular method of dealing with a range of social 'problems', and in so doing has created a new breed of professional called the 'advice worker'. This worker is accorded a quasi-official standing, by the people in the various other state agencies with which advice centres liase. The creation of advice workers serves to exclude a number of other possible approaches to the same problems. There is no longer any point in tenants' associations forming their own advice networks, through collective learning and the pooling of information, and there is a corresponding drop in local pressure on the state agencies to modify, or abandon, those practices and jargon that made 'advice' necessary in the first place. Instead of tenants coming together to achieve shared aims, individual tenants are encouraged to consume centrally produced pamphlets, which contain predetermined solutions to their problems.

I am not suggesting here that advice centres do not give good advice, nor that people do not benefit from this advice. What I am saying is that a state which funds advice centres clearly will not abandon the practices which make 'advice' necessary; and that advice centres, established as radical monopolies, make pressure on the state to abandon these practices that much less likely to arise elsewhere. Radical monopoly is thus the means by which the ideology of consumption is enforced. To understand how this general principle relates to cultural activism, and specifically to a community arts practice which is dedicated to social change, it is necessary to understand *how* radical monopolies affect the way people think and what they think about; and how they act as agents of an occluded social vision.

Chapter Twelve

Knowledge and information

As capitalism has expanded its areas of operations from the production of simple, tangible goods, through the production of services to the production of abstractions such as 'health' or 'education', it has moved from being a method of organising economic production to a method of ordering consciousness in ways which facilitate the consumption which must expand as capitalism expands, and at the rate capitalism expands. As a part of this process, radical monopolies have been established in which human needs are redefined as the needs for particular, and profitable, industrial outputs. The human choices involved in meeting those needs are reduced to a consumer choice, in which the decision is in which guise to purchase the industrial output.

We can see this process at work in areas of production as apparently separate as bread and photography. In both of these areas an existing practice was supplanted by an industrialised process, the outputs of which looked very similar but had radically different effects. The same process has occurred in the area of *knowledge*, which has been subjected to the radical monopoly of an industrialised, and centralised, output which I will call *information*. It is at this point that what might otherwise appear to be a set of abstract generalisations directly affect both the way people think and act, and the possibility of lived community.

Throughout history, people, of whatever class, have made sense of their lives from the meanings that they were able to derive from what they saw and heard, and from what they learnt. These meanings were themselves constrained by specific dominant ideologies, and by the generalised ideological currents which, at any time, comprise what passes for 'common sense'. Within these constraints, however, people were free to derive meanings, both individually and communally; and it was these meanings which provided the lynchpins for action. What they saw and heard, and what they learnt, was the knowledge from which they organised meaning. This knowledge (and I am including theoretical knowledge here) was at all times the attributable result of specific human actions, values and sentiments. It could be challenged and tested, and it could be organised into larger patterns. The acquisition of knowledge depends on the creation of

patterns. It is built up through a process of recognition, in which links are detected between apparently unrelated events; and, having been detected, make possible the discovery of further linkages. The acquisition of knowledge in this way, by a community, on however partial or constrained a basis, leads that community towards a collective competence in making decisions and taking actions. When power is exercised over a community which is competent in this way, it will need to be done directly and openly. The villagers will pay their taxes, not because they feel they 'ought' to, but because the King's men will burn down the village if they refuse.

Information, produced and distributed as an industrialised output, does not lead to competence in this way. Unlike knowledge, information is processed and shaped by professionals, and is neither directly attributable, nor easily testable. Rather, it is an apparently universalised communication which reaches us with no recognisable referent. Information is prepackaged. It arrives in discrete units which have already been interpreted and which are not rich nor complex enough in meaning readily to permit further interpretation. Crudely speaking, what is on the front pages of the newspapers is important because it *is* on the front pages of the newspapers. It is the producers, and not the consumers, of industrialised information who decide the contents of the package, and the prominence that will be given to the various items within the contents.[18] This is why public relations is such an important aspect of the production process within the high-intensity market. Before a new pop star can be manufactured, it is vital for the manufacturers to persuade the 'information industry' that she or he should be included in the current package. To fail to do this (to fail to get 'coverage') is, in effect, to fail to even get to the starting gates.

The replacement of acquired knowledge with centrally packaged information has a crucial effect on the ways in which meaning is constructed, and on the kinds of meaning that can readily be constructed. When meaning is constructed within a community, by means of the steady accumulation of acquired knowledge, then the concerns of that community, however localised or idiosyncratic they might be, will form the core of the process of constructing meaning, as well as providing its motive force. If, for example, a village is situated on the estuary of a powerful river, the concerns of the villagers are likely to lead them into a detailed understanding of tidal forces and seasonal cycles.

On the other hand, when meaning is constructed from the regular consumption of prepackaged information, the results are not an increase in competence in areas of localised material interest, large or small, but an increasing bewilderment, and a sickening dependency.

Information is packaged to be sold in amounts which are determined by criteria of profitability; and the consumers, like the consumers of white 'bread', are persuaded to adjust their own expectations to fit the requirements of the producers. The result is that people are displaced from the centre of their own lives. They no longer create, within communities, agreed scales of importance or agreed values, but are given these ready-made, as part of the information package they consume. They may, or may not, recognise that this is happening, but even where they do, this recognition is likely to lead to resignation; to acceptance of this as an unavoidable 'fact of life'.

Thus, the kind of news which directly affects specific groups of people is relegated to the bottom of the scale, where it becomes 'local news'; while the news at the top end of the scale is concerned almost exclusively with events which are outside the control, or experience, of all but a small elite. People's experience of living is inverted, and then sold back to them. The news is a kind of visual equivalent of hearsay, through which the public is expected to 'know' the people and the events portrayed, and to accept them as more important to them than the events which occur in their own lives. This kind of information is a window to a world for which there is no door. We ignore what is going on around us, and stand with our noses pressed up against the window trying to peer into this other world to find out what is *really* going on.

This process of inversion disguises the fact that the information we consume is neither neutral nor is it raw data from which meaning can be derived. It has been selected by a particular class of people to provide a particular range of views; and all we can do is to choose our 'own' point of view from within the range offered. The criterion used in the construction of this range of views is, directly or indirectly, one of profitability. The concern of those professionally engaged in the selection is, therefore, with a presentation which will keep people buying (or watching or listening or reading). Information is constructed in the form of a series of dramatisations in which each day's news is one episode in an ongoing soap opera — complete with its daily cliffhanger endings.

Information comes in the form of 'stories' about personalities, and not in the form of developed arguments about issues. A complex breakdown in labour relations at a factory, with causes which can be traced back many months, and which culminates in an overtime ban and eventual strike becomes something like: Striker's daughter Marie, 7, says 'I'm hungry'. Thus the myth that the views of the dominant forces in society are neutral, and apolitical, is maintained by removing the politics from the *issues* and relocating them within the *actors* in the daily drama. The miners' strike ceases to be discussed as a complex

series of questions about the social purposes, and the possible social benefits, of coal production as opposed to, for example, nuclear fuel; and becomes the story of two men. One of them is a wild extremist and the other is a sensible, mild-mannered man who wants to help us by saving the country money. The dispute ceases to be a political issue, and assumes the function of a plot device in a cheap novel; a backdrop against which the eternal conflict between good and evil can be fought out once again.

This happens whenever the production of information and 'news' is centralised, and distributed through an industrialised process to a mass public for the sake of profit, whatever the apparent content of the news might be. This kind of presentation, wherever it is the dominant mode of presentation, reduces people to the status of individualised voyeurs: concerned, perhaps, but helpless. Their everyday reality, the communities within which they participate, cease to be the centre of their attention, and are relocated as idiosyncratic and unimportant subdivisions of a larger World, the determination of which is out of their hands.[19] From being actors playing parts in a localised drama, they become items of scenery, mere props, in front of which world events are played out.

This is not accidental. It is linked to the capitalist mode of production. In presenting people with a constructed world which removes them from the centre of their own lives, it operates to constrain and curtail the meanings we construct, and specifically to replace the kinds of meanings which are jointly constructed, through the process of community, and which lead to social competence, with a range of pre-packaged meanings which are consumed individually and passively; and which lead to a bewildered helplessness. In its presentation of these selected, and pre-packaged, constructions as apparently neutral — raw data from which we can create meaning — the information industry constitutes a radical monopoly over the construction of meaning; and one which is pivotal to the industrialisation of consciousness, and the production of trained consumers.

The information industry has sought to replace what people normally refer to as meaning, or understanding, with an industrialised equivalent which although it seems very similar, has profoundly different effects. It has sought to replace what may be termed *primary understanding*, which people derive through the process of encoding a few of the infinity of possible relationships between things in the lived world into recognisable and useful patterns. It has sought to replace these with a kind of *secondary understanding* which is derived from the process of decoding a narrow range of finite, pre-packaged texts, in which the originating viewpoints have been

assiduously hidden. A view of the world which is constructed wholly, or mostly, from packaged, generalised information, and the secondary understanding that can be gleaned from this, will be highly fragmented, and the fragments from which it is formed will remain disconnected. This, of course, is the sort of world view which is most useful to the successors of Edward Filene, who have constructed, and who now operate, the capitalist, and centralised, high-intensity market.

The social processes through which primary understanding is derived, are, by contrast, denigrated and dismissed by the dominant forces within our society, because they are literally bad for business. Information is a commodity, or can be turned into one, in a way that knowledge is not. George Eastman realised this when he saw the potential profit to be made by giving people enough information to use a camera, while persuading them that they would be better off with no more information than that strictly necessary for this purpose. This principle has since been refined, and is now designed into the manufactured products themselves. Some cars, for example, are manufactured with parts that can only be adjusted, or removed, with tools which are deliberately made available only to 'the trade'; while the term 'user friendly' denotes a computer which is easy to use in a prescribed manner, not one which is easy to repair, modify or rebuild.

The suppression of primary understandings, and the knowledge that can be accumulated from them, is vital to the capitalist enterprise, for its very efficiency means that it has long surpassed the meeting of anything that somebody living 150 years ago would have recognised as human needs. It needs to promote an ever-increasing level of consumption, matched to the belief that needs can only be satisfied through a high level of consumption. This is maintained, and reinforced, by the process of *simultaneity*, which is at work within the dominant structural arrangements. Simultaneity is the process whereby, at any one time, the various aspects of the information industry all focus their attention on the same small range of events (the opening of a film, the publication of a book, a particular series of football matches), with the effect that these events become the popular issues of the day. This can happen, whatever the precise nature of the information which is communicated, since the process works by saturating the channels of information delivery so that firstly, it is almost impossible to remain ignorant of at least some aspect of the event being promoted, and secondly other similar events, which might compete for attention, are submereged.

In this respect, it really is true that there is no such thing as bad publicity. It does not matter whether or not the *Daily Mail* liked the film; only that it announced to its readers that the film was there, and

was something to be seen, and something to be talked about, at the same time as *The Sun, The Guardian* and *Time Out* all announced it to their readers. In this way another dimension is added to the cultural agenda: that of time. For the simultaneity that the various information media generate means that it is no longer enough to work through the dominant agenda to be 'cultured'; you have to do it in a particular order, and at a particular rate. Simultaneity is the mechanism whereby certain products are turned into cultural 'tickets', which are valid for a certain time only. The importance of these 'tickets', which can vary from a record in this week's top ten to a particular kind of trousers, is that they can be used to 'buy' the status of being 'modern', and the appearance of 'playing the market' successfully.

Broadcast television is the epitome of the technique of simultaneity, which regularly turns the ordinary into the spectacular simply by insisting that it *is* spectacular, and by crowding out the millions of other events with equal claims to attention. By feeding the same information to eight or ten million people simultaneously, it is possible to provide ready-made subject matter for the conversation of the majority of those people the following day; through the provision of an almost guaranteed point of contact. If you saw a programme on television last night, which is designated 'popular', you are almost bound to be able to find someone else who did, and in this way the information that we receive simultaneously becomes our point of contact, our common experience and our collective point of reference.

Television produces simultaneity 'naturally' as a part of its mode of distribution, due to the legal restrictions that are placed on its production and distribution by the state. Until the advent of video recorders, there was no choice but to watch things in the order in which they were transmitted; and no guarantee that something, once missed, could ever be seen again. Moreover, there are, at most, only four things being broadcast at the same time. However, because simultaneity is such a powerful marketing tool, which is selling people topics about which to converse, and with which to accumulate social status, other parts of the information industry have striven in various ways to emulate it. Thus the music industry, especially that part of it which is concerned with the manufacture and distrubution of popular music, has constructed its organisation around various hit parades and top thirtys.

It is much easier for the music industry to sell a record if a knowledge of it, or ownership of a copy, is seen as one of the 'tickets' which can, for a limited period, be cashed in for status. Not only is it easier to sell a record in this way, it is more profitable, because it telescopes all the marketing and distribution into a pre-arranged length of time, which is usually less than 20 weeks. This is a process

which might otherwise continue for an indefinite period, which would be considerably more expensive. It means that the record companies, and the shops they supply, can carry large stocks of a small number of records, which is a more efficient use of capital than carrying a small amount of a large number of records. It means, furthermore, that sales will reinforce each other in a way which is likely to maximise profitability. A much larger group of purchasers than the original group will (seeing that the record is successful, and is therefore one of this week's cultural 'tickets') buy it *because* it is successful.

Publishers, and especially those publishers whose business is the mass marketing of paperbacks, have moved rapidly in this direction, with the creation and publication of various hit parades, detailing the top-selling fiction and non-fiction each week. The purpose of these, and the massive advertising campaigns which publishing companies have started spending on a limited range of likely best-sellers, is to stimulate, within the consumers of paperbacks, a feeling of simultaneity. The feeling is generated that it is no longer enough just to read, nor to develop idiosyncratic personal preferences with regard to authors or genres, but that the sociable act is to read what other people are reading, at the same time that they are reading it. Thus Penguin Books emptied the annual budget of their advertising department on one book in 1982. This book was MM Kaye's *The Far Pavillions*, about which the public had previously heard nothing, and it sold over 400,000 copies in eight months.

Simultaneity is the process whereby our fragmented needs can be brought together into a form which is convenient for manufacturers to deal with and satisfy. It is a process which can be seen in its purest form in the fashion industry, where the purpose is simply to be the first one in your social circle to look the same as everyone else. This process can also be seen, however, as one of the main operating principles of the entire information industry. Its effect is to provide a hierarchy of importances in which today's news is always more important than yesterday's; and what is in the news is what counts.

In this the replacement of acquired knowledge with pre-packaged information is almost completed. There is now an externally measured scale of importances, which can act instead of the kind of scale of values which arises with the competence that knowledge brings. This scale of importances, like the information of which it is composed, is imposed upon people by a process of radical monopoly. The replacement of knowledge with information is a form of oppression, in that it removes people from the centre of their own lives, and seeks to sell them, by way of compensation, a back seat at the ringside.

Were people able to derive most of their understanding from

knowledge they had accumulated, they would be able to build a cumulative, and comprehensible, view of how their world operates. Not, it is important to note, how *the* World operates, but rather how that part of it, within which they are actors and participants, operates. As Graham Greene noted in *The Great Jowett*: 'No one lives in what you call the World: everyone has his own world'. This comprehensible view, the formation of which is a necessary condition of democratic participation, is the basis upon which people feel able to act. Knowing that their world makes sense, they feel able to act within it, and since the world makes sense to them, because of their ability to accumulate their experiences as knowledge, then they *are* free to act within it. As they act, and act successfully, so the boundaries at the edges of their world are moved; and the size of their collective world (that area within which they feel free to act) grows.

Where people receive most of their communications in the form of pre-packaged, and selected, information, then none of this is possible. Information arrives in a way which is apparently legitimised by the way it arrives: it is on the news as true, and it must be true because it's on the news. The effect of a world in which we are compelled to act on the basis of perpetually unconfirmed information is to downgrade, and devalue, knowledge, and the experiences that lead to knowledge. We can no longer trust our own experience as the basis for meaningful action, and we are encouraged, and sometimes compelled, not to as licensed professionals fight to establish radical monopolies over greater and greater areas of our lives. It is not enough that we feel ill, that we experience ourselves as ill, that we *know* we are ill. If we wish to be excused from working without running the risk of being dismissed from our employment, we have to get a certificate from a doctor confirming that *the doctor* has decided we are ill. If we feel ill when a doctor can find no conventionally acceptable symptoms, then we are not officially ill: we are malingering, or if we persist in our claims we are deranged.

In this way the determining agencies interact, and inter-relate, to promote, in the interests of profitability, a consciousness which is occluded, and individualised. Thus people who might be citizens are turned into consumers, and the decisions that citizens would make are downgraded into consumer choices. Although consciousness is always, and everywhere, occluded, in the sense that all social formations impose constraints and limitations, and there is no social arrangements which could free people from all constraints, the occlusion that occurs through the imposition of industrially produced information has specific intentions and specific effects. It promotes a passivity which is both individuated and disengaged, and thus depoliticised. Politics, in the sense of active debates and over-riding

commitments, in the sense of the recognition of the need for groups to engage in the political process, is replaced by a depoliticised politics in which consumers vote for the personality, or the brand, of their choice on the basis of advertising campaigns.

The radical monopoly of information over knowledge has removed from people, and from the communities within which people might make meaning, the ability to define their world, and handed the power to create definitions to a particular professional class, in the service of the dominant forces within society. It is used in the service of the dominant ideologies which have fuelled and which still fuel, the growth of centralised capitalism.

Chapter Thirteen

Imperialism

To imagine that there was in the past some magic moment, in which everything was just perfect, and that somehow 'we' spoilt it, is an adolescent pipe-dream. In this analysis I am not suggesting that the process whereby the possibility of citizenship was downgraded into the fact of consumerism, is a decline from some kind of Eden. There has never been a single moment when everybody was an equal citizen. Rather, the process has been one of broken promises, and unfulfilled potentials, in which the promise of citizenship for all, with the advent of universal suffrage, died in its infancy, due to the dominant structural arrangements around which our society was, and is, organised.

These social arrangements which permeate our society, and through which we not only enact our business but also define what that business is, are all of a kind. These arrangments are the source of the iniquities and oppressions within our society. Racism, for example, does not spring from the actions of individual racists, although such people should be opposed, but from those structural arrangements in our society which proceed from racist assumptions. Similarly sexism, although *embodied* in the actions of individual men, *arises* from those structural arrangements in our society which proceed from sexist assumptions. To understand how and why this happens, we must look at the development of the dominant institutions, and the social arrangements which underpin them, within our society.

Most of the powerful institutions in this country spring directly from, or are recognisable descendants of, the lengthy period of concerted growth which capitalism underwent in the nineteenth century, following the industrial revolutions of the late eighteenth and early nineteenth century. They are themselves a part of the wider story of that growth. The assumptions which, initially, underlied them may be traced back, then, to the concerns of the successful and properous industrialists of emergent British capitalism; and to the concerns which they had themselves inherited from the land-owning gentry of the late eighteenth century.

One of their main concerns was the expansion of the British Empire, and the resulting growth of trade routes which would enable them to purchase, cheaply, the increasing amounts of raw materials

they needed, while providing them with a growing market for their manufactured goods. The growth of the Empire necessitated the growth of a correspondingly powerful group of bureaucracies and administrations, and it also brought with it a particular set of views and beliefs concerning the relationship of a man to his Queen and Country, the rightful place of women, and the obligations and duties of a civilised man towards untutored natives. These beliefs found their most explicit cultural expression in the genre of 'boys' adventure fiction' which became popular during the latter part of the nineteenth century, and which continued to be written and read until the Second World War. This ideology was given a tangible reality in 1908, when Baden-Powell established the Boy Scouts, for the express purpose of inculcating in young boys what had, by that time, come to seem a natural phenomenon: the English Gentleman's way of approaching the world.

In one sense, the Boy Scouts represented an attempt to bring the Empire back home; but they were, by no means, the first time that this had been done. Indeed, throughout the latter half of the nineteenth century there was a sense in which events abroad were being parallelled by events at home. The new ruling classes, formed from the older landowners and the rising merchants and industrialists, found themselves dealing with restless 'natives' in India and Africa at the same time as they were dealing with a growing working class movement in England. In the 1870s and early 1880s there were riots, or near riots, in London by the unemployed, by Radicals, by Socialists and by Irish Nationalists, which even the recently reorganised Metropolitan Police found difficult to contain.

The Chief Commissioner of the Metropolitan Police, who was appointed in 1886, was Sir Charles Warren, who had a background of military service in the Empire. He had gained his military experience in Gibraltar and Griqualand West, and had commanded the Diamond Field Horse in the Kaffir War of 1877 and 1878, after which he had been the military and civil administrator of the Bechuanaland protectorate. He was, according to EP Thompson, 'a representative figure of the imperialist climax; and he reminds us of the inter-recruitment, cross-posting, and exchange of both ideology and experience between those who learned to handle crowds, invigilate subversives, and engage in measures of 'pacification' in the external Empire, and those who struggled with the Labour Problem, the Unemployed Question, the Women Problem, and sometimes just the People Problem, at home'.[20]

Beliefs and ideologies do not, at any one point, stop in their tracks to be replaced by another discrete set, but rather wax and wane slowly. The imperialist ideologies persist, in modified forms, to this day. They

were taken over by succeeding generations, and slowly adapted to changing circumstances, just as the governing bodies of the mid-nineteenth century took over, and adapted, the ideologies of the eighteenth century landed gentry. The characteristics which informed the structural arrangements that were set in motion during the years of expanding Empire included a sense of God-given rightness, which was linked to a paternalistic belief that this rightness carried with it an obligation to assist those less fortunate. It was a muscular Christianity, 'paid for' by adopting the White Man's Burden. When these characteristics were turned inward, and applied to England itself, they produced the philanthropic puritanism which drove the Victorian upper classes to try to 'improve' the working man, and which led, therefore, to the establishment of museums and galleries in provincial towns, wherein working people could be instructed in the finer arts.

Behind the desire to instruct the 'uncultured' working classes, and raise them to the status of the cultured, lay several assumptions, not the least of which was the assumption that they were, in fact, uncultured. What had happened was that the interests of one group within society, that powerful group which ruled the Empire abroad and the factories and land at home, had come to set the standards of what it meant to be a cultured person. The tastes of this group were connected to what, in a previous era, had been the *court arts*; and they were located here for a variety of reasons, some of which were to do with education, and some of which were to do with aspirations of a newly ascendant group to legitimise itself socially. The tastes of the working classes, as a class, were largely drawn from what had previously been the *folk arts*. These differed from the court arts in being, in the main, passed from generation to generation orally, and in being collective, rather than individual, in orientation, with much emphasis on participation. The unspoken assumption of the cultural missionaries was that the folk arts did not count as a part of 'culture', and that a knowledge and love of them was not connected with the civilising influence of culture, which could only be transmitted through the court arts. The latter came to be seen simply as 'the arts'.

The prime movers in the field of cultural missionary work were religious movements, and the wives of politicians and aristocrats. The effect of their 'charity' was to stigmatise the very people whom they imagined they were helping. Thus the Salvation Army created categories for those it helped (poor girls, prostitutes etc), into which they were slotted. This approach lives on today in the use of such spurious notions as 'cultural deprivation', with its implication that those people happily playing darts (or push-pin) need to be helped across the road into the opera house. It lives on too in the creation of a

'voluntary sector', whose business is to tend to certain officially approved categories of the 'disadvantaged'.

Indeed, most of our cultural institutions today are linked directly to this history. The Arts Council of Great Britain was founded after the Second World War, for example, in order to carry out the wartime work of CEMA, the Council for Education in Music and the Arts, which Maynard Keynes had established to instruct those working people engaged on the home front in 'the serious arts', in order to keep their morale high.[21] We can see the discrimination against folk arts, or against any creative endeavour which falls outside the narrow range of the court arts, in the way in which the Arts Council was established. During the war CEMA had been one of two such organisations established to cater for the need for morale-boosting entertainment. The other organisation was the much more widely known ENSA, which undertook similar work, using performers from the popular arts: from dance bands, music hall, the wireless and the like. The work of ENSA was not incorporated into the brief of the Arts Council, however, when it was established in 1945; and nor was it for more than 30 years after that.

The work of the Arts Council was perceived, essentially, as that of nurturing the Great Tradition of European Art, and protecting it from philistinism. This Great Tradition is itself an ideological construction of the imperialist climax, and is profoundly Eurocentric in its assumptions. Its apologists believe, or act as though they believe, that civilisation was invented in ancient Greece, reached a zenith in Renaissance Italy, and was subsequently carried to those unfortunate parts of the world that had missed out on it by white explorers and servants of the Crown. This should not be surprising, for the Great Tradition is a cultural formation which is linked to the muscular Christianity which was the official religion of British imperialism; and which was, indeed, carried to the colonies in just such a way. From time to time, this Great Tradition has been seen as the secular counterpoint to that religion, and in many ways it is. It is a cultural formation which extolls certain viewpoints by demeaning all others: by deriding them as 'pagan'. Thus the civilisation of Egypt, for example, or the other African civilisations, are reduced to mere footnotes in the history of 'real' (ie Eurocentric) culture.

In the Great Tradition there is a pyramidal hierarchy of artists and artistic work. It is this hierarchy which provides the historical continuity of the Tradition and, through its very slow change, the foundation for the assertion that 'great art' stands outside history and politics, from which vantage point it reveals eternal truths. This hierarchy is the cultural heritage of those who control it, and who package and sell it to us, and which they would have us accept as

'objective'. Great art, we are told, is that art which has passed the test of time, as if all creative endeavours had an equal opportunity to take the test. In fact, most creative activity is expressly prohibited from entering the examination hall.

The structural relationships which permeate our society are post-imperialist, and they carry with them many of the ideological features of the imperialism from which they spring. They have seized the power to label and define, and the power to promote those activities which they define as good. They do this at the expense of all those activities which they define as bad, or which fall outside their preferred categories. They have become part of a network of radical monopolies, operating through a process of simultaneity; and they are used to propagate ideas, and to manufacture information, in the spheres of politics, employment, consumption, culture and morality, which are necessary for the maintenance, and further expansion, of the high-intensity market. This high-intensity market is *necessarily* imperialist, for it is based on an infinitely expanding rate of consumption. It has brought the Empire back home, but it has not abolished the Empire. It has created machines to replace many of its colonial slaves, but it has not abolished its reliance on slavery. Its use of machinery is largely based upon the profitable 'illusion that men are born to be slave holders and the only thing wrong in the past was that not all men could be equally so'.[22] The freedom it offers is essentially the freedom to kick the cat; the freedom to occupy the next to bottom rung of the ladder, and look down at the occupant of that bottom rung.

Machines have, in many cases, replaced the human proletariat, who functioned in conditions of near slavery in Victorian times, as the surplus generated by capitalism has promoted the workers to the role of bourgeois consumers of the goods that they produce. Machines have not, however, replaced the desire to conquer (and the desire to divide the world into conquerers and conquered) which was the motive force of imperialism. The need to maintain an accelerating rate of consumption has led only to a change in tactics. The relationship between master and slave has been modernised, but it has not been abolished. Instead it has been harnessed for use as an inducement to the working class; an indication that in the world of high-intensity consumerism, *everybody* is powerful. Domestic appliances are sold as though they were servants: the more modern they are the less *you* have to do, and the more you can stand there watching them work to your command. Frozen food is sold on the basis that it makes, 'every meal a gourmet meal': as though its purchase means that somewhere a trained kitchen staff is working for *you*. In exchange for a debilitating passivity, the high-intensity market makes us all masters of our own hoovers.

Underlying capitalism is a need to conquer, an imperialist drive, which steam-rollers everything in front of it, and which has now turned in upon itself, so that it is conquering the consciousness of its own troops. This is not an accident, and it is not an aberration. It is the result of the growth of a dominant system based on the belief that the creation of surplus value is a value in its own right. It is these systemic forces which create the specific miseries, and oppressions, under which we, in our differing ways, suffer. Racism is not *just* a matter of individual racists; it is the result of a system which has discrimination, conquest and pillage built into its very structure. Sexism is not *just* a matter or individual sexist books, films, advertisements, acts or men; it is the result of a system which depends upon the propagation of discrimination and the creation of oppressed groups. It is the result of a system which justifies its successes by other people's failures, and which ensures its own success by systematically crushing other groups into failure.

The capitalist mode of production has, through this history of development, ceased to be a form of economic organisation, and has become a method of organising the consciousness necessary for that economic organisation to flourish and grow. In this it differs from other forms of economic organisation, which operated as one 'estate' within a wider society. Thus the morality which underpinned feudalism was in the hands of the Church, which formed a separate estate, distinct from 'commerce'. As long as the Church maintained that usury was a sin, feudalism could not be superceded, for money could have no value in its own right, and could not be invested or earn interest. Only when this doctrine was modified, and abandoned, could capitalism begin. Capitalism differs from previous forms of economic organisation because it has sought to make the construction of the ideologies which would best suit it a central part of its own business. It has sought to create, through the use of radical monopolies, a society which has only one estate, and can envisage no others.

This system cannot be reformed by the introduction of guidelines and safeguards, or by the establishment of extra provisions for the 'disadvantaged', although this has been tried. Attempts have been made, for example, to combat the cultural effects of racism by the introduction, in the state funding agencies, of ethnic arts committees, serviced by ethnic arts officers. This strategy only compounds the alleged problems rather than solving them. It is an attempt to relocate the effects of racism, so that they become a problem, not of European culture, but of something called 'the ethnic arts'.

The existence of substantial bodies of work, emanating from the cultural histories and traditions of Africa, India, Asia and the

Caribbean, yet being practised and developed in Britain, poses a central challenge to the entire basis of the Eurocentric and imperialist Great Tradition. These works simply cannot be incorporated into a hierarchical values of the Tradition because their practice, their social meanings, and the ways in which they are appreciated and evaluated, are different. They arrive from very different starting points and they aim at very different goals. The liberal solution to this 'roblem' is to create a new division of the arts, the ethnic arts, but this is a diversionary nonsense. This attempted solution pretends that it is possible somehow to take the citadels of 'serious' art, and build an additional room on the back, while leaving the main buildings untouched. Black artists are to be allowed into the grounds, where they will have their own hut, just so long as they don't bring their 'pagan' ideologies into the main buildings. This is not a genuine multi-culturalism, in which each learns from the other, and both are changed by the experience. It is a process of incorporation and Westernisation, which continues, albeit more subtly, the work of imperialism.

The truth is that the problem lies in the structure of this society. The existence of new art, produced in Britain by British artists whose historical and cultural roots lie in the Third World, provides a final demonstration of the oppressive nature of the Eurocentric Great Traditiom, and its imperialist assumptions. This single hierarchy of imposed values makes impossible any pluralistic assessment, since it insists on referring all assessments back to the same starting point, and judging them by the same narrow, 'God given' standards. This it does with any creative activities it does not recognise as its own; whether they originate from another class, another sex, another race, or another political stance. The truth is that the citadels need to be taken apart, brick by brick, so that we can use the bricks to build a whole collection of new buildings; smaller and less impsoing, but designed for freedom of movement. If we are to assist in this process, as community artists, then we need to develop a programme which will enable us to move the opposition to this oppressive system into the realms of culture and sociality, as they are lived by ourselves and by other working people.

We need to challenge, not just the manifestations of oppression, but the imperialist structures which nurture and propagate these opp-ressions. We need to realise the nature of the dominant political framework within which we are working.

Notes

Chapter Six
1 In all of these roles it acts to supervise and coordinate activities within what Marx termed 'the sphere of necessity'.
2. *Culture*, chapter 4. (Fontana, 1981)
3. Andre Gorz, *Farewell to the Working Class* (Pluto).

Chapter Seven
4. Reprinted in *Winstanley: the Law of Freedom and other writings*. (Penguin, 1973).
5. See for example, Raymond Williams *Culture and Society 1780-1950* (Penguin). G.D.H. and Margaret Cole edited *The Guild Socialist: a journal of workers control* from 1919 to 1925. This regularly included articles by, among others, A.J. Penty. See for example *Social Credit and the Guild Idea*, a polemic in the June 1922 issue.
6. *Culture and Society 1780-1950* (Penguin, 1958).

Chapter Eight
7. See *Art, an enemy of the People*, by Roger L. Taylor, (Harvester, 1978). Chapter 2 is particularly relevant to this argument.
8. Ed Berman, in an interview in *Another Standard*, Summer 1983.
9. The Works of Jeremy Bentham, volume 2.
10. *Culture*, chapter 5. (Fontana, 1981).

Chapter Nine
11. The technical aspects of these arguments are dealt with in considerably more detail in Dermott Killip and Owen Kelly, *Shooting People Is Wrong*, (Mediumwave). An edited version of this essay was printed as *Cameras as Convivial Tools* in *Camerawork* number 22.
12. Pinhole photography uses a simple lightproof box with a single pinprick which acts, like a lens, to focus the light which enters.

Chapter Ten
13. William Leiss, *The Limits to Satisfaction*, (Marion Boyars).
14. Hannah Wright, *Swallow It Whole*, (NS Report no 4).

Chapter Eleven
15. Evidence for this is quoted in Ivan Illich, *Limits to Medicine*, (Penguin), from *Prospects in Health* (Office of Health Economics, Pubn No 37). See also R.G.S. Brown, *The Changing National Health Service* (Routledge).
16. For an autobiographical account of his aims and methods, and the opposition they aroused see A.S. Neill, *Summerhill*, (Penguin).
17. Ivan Illich, *Tools for Conviviality*, (Fontana).

Chapter Twelve
18. An extreme example of one aspect of the difference between knowledge and information is provided by the activities of ProActive Systems, Inc. They provide shops, hospitals and offices in the USA with self activating sound systems designed to play prerecorded messages at a volume just below the threshold of conscious hearing. These subliminal messages are claimed to reduce shoplifting and office theft from between 25% and 90%. In a very literal sense they have no attributable referent. Information on this system was provided in *Omnibus*, (BBC 1), July 1st 1984.

19. The exception to this lies in those comparatively rare occasions in which a group of people find their local struggles being used as a set for the fictional drama of the information industry. Thus the miners on strike will find, for a limited period and within a specific range of limitations, the interests of their communal world one of interest to the World at large.

Chapter Thirteen

20. *The Secret State*, by E.P. Thompson, published as one of the essays in *Writing By Candlelight*. (Merlin, 1980).

21. The 'inter-recruitment, cross-posting, and the exchange of both ideology and experience' which E.P. Thompson has characterised as typifying the imperialist climax, can be seen in the founding of CEMA, which was initially appointed as a Committee by the Pilgrim Trust. Its secretary, Dr Thomas Jones, reported its founding in *The First Ten Years*, the eleventh annual report of the Arts Council. He said that 'it began on the telephone. Lord de la Warr, then President of the Board of Education, rang up the Secretary of the Pilgrim Trust to sound him out about an "idea" and a possible grant; nothing very much. £5,000 perhaps. A familiar experience. The "idea" sounded promising on a first hearing, and it was arranged that the President of the Board should meet, without prejudice, the Chairman of the Trust, Lord Macmillan, then Minister of Information.

Lord Macmillan's grave judicial calm collapsed . . . He was responsible for the national morale, and . . . he saw employment for actors, singers and painters, and refreshment for the multitude of war workers for the duration. Supply and Demand kissed. Would £25,000 be any use? The Secretary blushed and fell off his stool.'

22. Ivan Illich, *Tools for Conviviality*, (Fontana).

Part Three

A programme for community arts

Chapter Fourteen

Cultural democracy

The history of community arts is the history of a movement of naive, but energetic, activism which, bereft of analysis, drifted into the arms of those groups it set out to oppose. Fuelled by a liberal pragmatism, which claimed it was better to do *anything* than to risk doing nothing, it seized whatever money was offered, with little thought for the possible consequences. It organised itself only to the extent necessary to demand more money. Addicted to grant aid, which was provided at all times in amounts and in ways which suited the funding agencies, it could only scream for a regular increase in the dosage. It became incorporated as a quasi-independent subsidiary of the welfare state, and although it 'did good', it was no more revolutionary than the district nurse.

This did not happen to *all* community artists, nor to all community arts groups. Some did have a clear analysis, and a clear idea of their objectives, and a set of strategies to enable them to use funding, rather than be used by it. Telford Community Arts are an example of this kind of group, and as a result their relationship with their funding agencies has run considerably less smoothly than is normal. They were atypical, however, and their ideas, and the ideas of groups like them, were never able to achieve dominance within the Association of Community Artists, which remained entrenched in a hopeless pragmatism.

The aims of community artists, in so far as they were openly stated, were not in principle incapable of being realised. Their achievement, however, would have required an understanding of the context within which they were to be attempted. It would have required an understanding of the specific ways in which capitalism has encroached on the previously 'private' areas of consciousness and sociality, and it would have required strategies designed to oppose this. It would have required the recognition that capitalism has grown far beyond the boundaries of mere economic organisation, and the realisation that this may be applauded, or opposed, but cannot be ignored by any cultural movement that expects itself to be taken seriously. This necessary process of analysis is not a task that can every be finally completed, nor is it a task which can be done separately, or prior to, practical action. Instead, it must be seen as a

part of that action, and must grow out of, and feed back into, it. In this way both analysis and action merge into a programme, with a clear set of aims, and a set of strategies for achieving them; and practical actions (which pragmatists insist are the 'real work') become part of a wider purpose.

In constructing such a programme, it is important to remember that art is not politics, nor can it be. Art itself cannot bring about political change, as Linton Kwesi Johnson has pointed out. 'I don't believe poetry changes anything. I don't believe art changes anything. Art reflects changes within the wider society. Changes comes out of people's material struggles in life.' [1]What community artists can do within their work is to assist those struggles, and to participate in the development of the consciousness that fuels them. They can construct images, events and statements which are *congruent* with those struggles: positive images which may well have an important role in sustaining and encouraging the *struggle towards competence* that needs to be made. The role of the community artist must be to devleop those practices which are congruent with 'material struggle', and oppose those practices which are part of a consciousness which is fragmented, bewildered and defeated.

This fragmented consciousness is the consciousness of the trained consumer, the compliant purchaser who has been taught that democracy is being allowed to choose between the different packets on the supermarket shelves, and that the choice of what should be put on the shelves in the first place is a job for experts. If this consciousness is to be opposed and superceded, then the separation of the producer from the consumer must itself be challenged. The development of this mode of industrial organisation was envisaged by clear-sighted businessmen as a means of fostering an ever-rising demand which they could meet by increasing production. The producer/consumer mode of organisation, then, is neither neutral nor 'natural', but reflects the interests of those who control it. If we are concerned, as a movement, about widening and deepening democracy, we must inist on access to *social input* as well as social control over the state's output.

The idea of democratically controlling *social input* is complicated to define, and far-reaching in its consequences. It is also, I believe, a necessary corner-stone in the construction of any genuinely oppositional cultural movement. I will explain it with an example that relates directly to the history of community arts.

Sir Roy Shaw, until recently the Secretary-General of the Arts Council of Great Britain, has long accepted that the arts do not reach enough people, and are presently too much the province of a small group. He has argued persuasively that this is not simply a matter of

finance, 'since people pay high prices for pop concerts or a night in one of the many variety clubs or "night clubs for the masses" that now cover the country. The barriers are largely educational. People feel that the "high" arts are not for them, as is shown by innumerable studies of the audience for the serious arts both in Britain and America'.[2] To combat this, he has argued for a democratisation of culture, by which he means that there should be a programme of education in the arts, along with intelligent popularisation, in order that the idea that ballet, theatre, painting and opera are pursuits solely for the middle classes might be overcome. Then, he argues, the great mass of people might be persuaded to watch and gain from them. This is not an unusual view. It has been put forward by many others, too; and it has permeated the thinking of many organisations, even 'left wing' organisations. It can still be found in such contemporary organisations as the National Lobby for the Arts. This view also contains worthy sentiments, which proceed from the idea that there are many things of value in 'art' and that as many people as possible ought to be persuaded to benefit from those values. In other words, the cultural outputs of our society must be made available to all, and should be distributed throughout society on as equal a basis as possible.

Community artists have argued, on the other hand (and admittedly at times in an unclear and confused way), that the democratisation of culture, in the way that Sir Roy Shaw suggests, does not go nearly far enough, and does not, in fact, tackle the real issues at all. What is required is *cultural democracy*. This does not mean, as Lord Gibson apparently supposed, that community artists 'reject discrimination between good and bad', but rather that they ask why there is a centrally controlled, and coordinated, set of cultural outputs at all; and wish to enquire who it is that selects the content of this set, and on whose authority they do so. For Sir Roy Shaw's argument to have any force, it is necessary to believe that this centralised cultural package, or agenda, arises 'naturally', and without prompting. If it arises 'naturally' then the benefits it bestows are objective benefits, of equal worth to everyone who samples them. In this case, it becomes almost a moral duty to show as many people as possible the benefits they are missing out on. If, however, the cultural agenda is the work of one small group, and represents *their* interests and values, the position is very different. In that case, the 'benefits' that people derive from works of 'art' will vary from group to group, and the attempt to impose the agenda of one particular group on the rest of society will be an oppressive imposition, a radical monopoly exerted by a certain way of seeing and organising experience.

Indeed, it is perfectly possible to deny that the democratisation of

culture (that is, the popularisation of an already decided cultural agenda) is a good thing, and to argue instead that the agenda itself ought to be destroyed, without denying the power of any of the individual works on that agenda to move, educate and illuminate many people. Some, Sir Roy Shaw among them, have claimed that the argument in favour of cultural democracy is tantamount to arguing that there is nothing of worth to be found in Dante, or Shakespeare, or Milton, or Donne. To rebut this, Sir Roy has gone to great lengths to demonstrate that the works of these authors can enrich the minds and lives of 'ordinary working people'. In reviewing Su Braden's book, *Artists and People*, he writes that 'perhaps Ms Braden has never seen, as I have, a group of miners' wives enjoying Yeats and Auden and saying with delighted surprise: "Poetry was never like this at school". Any adult educator in the arts could list innumerable such instances.'[3] This is undoubtedly true. I would certainly not deny it, and I doubt Su Braden would. The problem, however, is that, for whatever reason, Sir Roy Shaw is confusing two quite different levels of argument; possibly because the cultural package in question coincides so exactly with his personal tastes and expectations that the confusion is completely invisible to him.

The acts of production and consumption are, as I have indicated, two complementary classes of activity, neither of which is inherently right or wrong, but either of which, performed in isolation from, or in ignorance of, the other, is on its own incomplete. The argument is not about the benefit, or not, of reading poems which are 30, 40 or 70 years old; but the dubious assumption that this could, on its own, form a substitute for direct participation in the production of a living culture. The knowledge that arises from such participation is much more likely to lead to those collective understandings which I have termed *primary* than the (admittedly interesting, illuminating and sometimes important) information that results from the decoding of a finite literary text.

The current argument in favour of the 'democratisation of culture' goes hand in hand with the tightening of professional control over the production of cultural outputs, for it suggests that what we need is more of what we already have, given to us by better trained versions of the people who are currently trying to give it to us. For most people this will simply produce a higher level of externally directed cultural consumption, which would be the direct antithesis of genuine human creativity. This consumption would be at the expense of other 'unofficial' pleasures, for unless certain forms of pleasure are derided, or disenfranchised, there cannot be the agreed hierarchy of values which is the necessary precursor of the centrally coordinated cultural package, more usually referred to as 'serious art'.

Cultural democracy, on the other hand, is an idea which revolves around the notion of plurality, and around equality of access to the means of cultural production and distribution. It assumes that cultural production happens within the context of wider social discourses, and that where the cultural production arises out of, and feeds back into, these wider discourses, it will produce not only pleasure but knowledge. This knowledge, large or small, will accrue to the primary understanding of community, whereas the information gathered from the study of texts chosen for their 'importance', by an externally controlled hierarchy, will not. The latter will lead only to weak *secondary understanding*; formally recognised but fragmented. From this perspective, the democratisation of culture can be seen as the compulsory imposition, on society at large, of the values of one particularly powerful group. These values appear as neutral, and as natural. Their imposition serves to downgrade the value of the preferred activities of other groups within society, which are designated as hobbies, folk arts, ethnic arts — or just plain quaint.

This example is particularly apposite, because it shows how even well-meaning intentions to democratise access to cultural outputs can lead to a crippling decrease in access to the means of cultural input. This is not a problem which is confined to 'the arts', or cultural activities. It runs through all those activities which flow from, or through, the centralised and centralising state; and it bedevils all attempts to achieve social change by equalising the consumption of centrally produced, or organised, commodities. The compulsory imposition of centrally controlled systems of value is poisonous, and there is no such thing as a fair or equitable dose of poison.

Along with the demand for cultural democracy, therefore, must come the demands for political democracy, for industrial democracy, for economic democracy. In each of these spheres, and in many others, we should demand the freedom of citizens rather than the 'rights' of consumers. We should be free to help determine the social arrangements and agencies by which we are, in part, determined. The role of an oppositional cultural movement, such as the community arts movement, should be multi-dimensional. It should champion the cause of cultural democracy for three reasons. Firstly, it is congruent with the development of the consciousness that is necessary for sustained material struggle. Secondly, it is a necessary part of the struggle to invert the high-intensity market, which has industrialised the production of consciousness. Thirdly, it has a prefigurative role, through which people's expectations are raised, and made more specific in other spheres. The community arts movement must take the idea of cultural democracy as its overall aim, and with regard to that aim, it must clearly, and loudly, demand the decentralisation of the means of cultural production.

Chapter Fifteen

Common organisation

Like the abolition of nuclear weapons, or the overthrow of the ruling class, the decentralisation of the means of cultural production will not just happen. It will need organisation, persuasion and mobilisation. Even with organisation it will not happen at once, as a result of one easily identifiable action. It will occur as a result of a complex series of struggles and movements, primary among which will be the struggle for competence.

Competence is defined in the Concise Oxford Dictionary as a 'sufficiency of means for living; ability to do; legal capacity and the right to cognisance'. In its fullest sense, it is a minimum requirement for communities who wish to be anything other than supplicants and dependents in their relationships with the centralised state. It implies the ability to acquire and accumulate knowledge, and the time and space to organise this knowledge into meaning and understanding; and over and above this, the power to turn those meanings into decisions and actions. This competence partly results from the intersection of lived community and cultural production, or 'art'. Community artists must organise so that, whatever the specific local results and effects of the work they do, the *overall* effect is an increase in competence for the communities in which they participate, and a conscious realisation that this competence has been achieved. For this to occur, individual projects, or pieces of work, must be tied to a larger vision; a cumulative period of growth of what may be termed *social capital*.

Social capital stands in distinction to the dependency created by the 'free' services offered to voluntary groups by the state. These 'free' services lease workers, or services, to groups at the cost of their tacit agreement to the overall aims of the agency organising the leasing. In this way, groups are co-opted, and eventually incorporated, within the overall service provision of the funding agency. The gains that these groups have made are often fragile, and sometimes illusory. If the services are withdrawn by the funding agency, then the group that has been receiving them will often collapse, since the services provided by the funding agency are all that is holding it together. To avoid collapse the group is drawn into further collusions with those providing the funding. In adapting its work to better meet the priorities and

emphases of those funding it, a group can often lose sight altogether of its original starting point, and its initial aims and purposes.

This type of 'gain' is unlike the type of gains that are made when a group, such as a tenants' association, holds a jumble sale to raise money to purchase duplicating equipment. Here, the tenants donate their labour, and in exchange they get, through the proceeds of the jumble sale, duplicating equipment which they own collectively. The equipment is theirs, as a result of their collective labour, and cannot be reclaimed, or redirected, by a funding agency. Moreover, the labour expended in obtaining it is part of a cumulative struggle, which can subsequently be built upon. The equipment, having been paid for in this way, can be used by the tenants to produce a newsletter which does not, from its very beginning, rely on grant aid for its printing costs. Cultural activity can thus grow into cultural activism.

This method of organisation depends on the recognition that, in a capitalist society, constructed around the notion of profitability as a value in its own right, money can never be neutral. Attempts are regularly made to pass money off as a neutral, natural resource, and community artists have all too easily fallen prey to them. The peculiar notion of community control, which is advanced by funding agencies, is one such attempt. This idea begins with a view of 'a community' as a simple and static statistical unit, and then proceeds to argue that, if a grant is given to a group which is deemed to lie within that community, then that group should be responsible to, and controlled by, this fictitious community. As a result, the group's activities, the management, will always be inquorate, and always open to the charge that they are unrepresentative.

The development and funding of community arts work has been largely class specific. Debilitating 'free' resources have been created mainly in working class areas, under the direct or indirect control of people who are neither working class, nor would wish to be. The advantage of 'free' resources is that they keep a considerable number of people safely out of mischief; and moreover, keep them out of mischief in a way which leads them, in all sincerity, to believe that they are making big trouble. This happens through the simple procedure of defining community arts activities as dependent on grant aid, while simultaneously defining grant aid as a scarce natural resource. In these circumstances, the hunt for grants becomes a major task and, once one has been captured, the task of keeping it alive, from year to year, becomes a full scale preoccupation.

Revenue funding of the sort that the Arts Council, and subsequently the Regional Arts Associations, give out, creates an apparent need for 'community control' which is both spurious and damaging. This need springs from the fact that this kind of revenue funding inevitably

creates monopoly resources, and these are deemed to need 'responsible' management. Revenue funding creates monopoly resources because, by its very nature, it creates demands it cannot meet, which must then be 'prioritised'. For example, if an Arts Association has £1,000 to spend it will attract applications for £5,000; if it has £100,000 to spend it will attract applications for £500,000. The more money that is given out, the more visible the work that is being funded becomes; and the more visible it is, the more people are likely to think of emulating it. Once this process gets underway, funding agencies develop 'priorities', which come to form a preliminary assessment procedure.

These priorities take a variety of forms. Some Regional Arts Associations, for example, have used the idea of *geographical spread* as their way of deciding preliminary priorities, while other Arts Associations have 'targeted' certain art forms, or specific social groups. When the Greater London Arts Association introduced the notion of geographical spread, it quite explicitly created monopolies, although this was not its ostensible purpose. This policy declared that it was not right that one area should have two printshops, or darkrooms, or mural groups, or whatever, while there were other areas that did not have any. Since, in practice, there was never any likelihood of there being enough money available to fund every application, the first printshop, or darkroom, or mural group, established in an area would very likely be the only one that would get established there. Within its alloted territory the resource would be an effective monopoly, and its work would become constrained and directed by the obligations to work with the 'whole community' that are imposed by monopoly status. All partisan initiatives become relegated to the sidelines because of the perceived need to treat the demands of all the very different groups in the catchment area fairly and equally. Thus no work with, say, a Black group can be allowed to develop to the point where it is eating into the time available to the local pensioners' group, for to allow this to happen would be to act in an 'unrepresentative' manner.

Would-be revolutionaries, who are salaried by the state, will always be trapped within contradictions which will derail or destroy any gains they make. The notion of community control, fostered by funding agencies, leads to a position where we are forever worrying about the people who aren't there, at the expense of developing our work with those who are. The kind of 'community control' under which community arts groups are encouraged to operate is almost always an illusion, for the real control remains with the state. It is the state that has the power to increase, or decrease, or withdraw, the funding which enables the activities to take place, and this power is

never handed over to 'the community'. Community artists, like community workers, often end up *increasing* the amount of monopoly resources which the state controls, in order that we may assist an alleged 'community' to manage them. Both areas of work have moved far beyond the stage where local activists worked with their neighbours, who were in more or less the same boat as themselves, for their mutual and collective benefit, to a point where professionalised workers persuade their 'clients' that they need what only the state can provide.

This serves to hamper competence arising within the social networks where community is possible, and to curtail it wherever it does manage to develop. People are persuaded that action can only arise as the result of an increased consumption of externally controlled grants; and ironically, each grant-addicted community arts project becomes a further piece of evidence for those who assert this. This kind of action, however, is incompetent and weak. Competence will not arise through the consumption of grant aided activities because, although a photography project, for example, might teach people how to take photographs, it will not usually be able to teach them how to obtain the resources to build a darkroom of their own. The project becomes impossible for each user group to duplicate, and remains in their mind as a piece of momentary good fortune. Although the day-to-day practical use of the resources may be demystified, the supply of those resources will remain opaque. Help arrives from an unattributable, and unknowable, source and its arrival can only be interpreted as an unpredictable facet of the way things are. Whenever the line of supply of a resource remains opaque, people are seduced into a bewildered dependence, and induced to mistake temporary abundance for freedom.

These contradictions arise because we fall into the trap of believing that, because state funding is derived from taxation, we are responsible to all those people from whom tax has been taken. The state, it is said, either does, or should, tax the rich to help the poor; and one of the aims of radical action should be to increase the extent to which this actually happens, and the availability and utility of the social benefits that result from it. However, the taxes which are levied do not go directly to the poor. In the main they reach them (when they reach them at all) in the form of 'free', professionally determined services, which are not just financed by taxation, but are also legitimised through taxation. This process of legitimisation, whereby things are said to be done on our behalf simply because they are paid for through taxation, is an invisible and debilitating aspect of taxation, which arises whenever it is used to finance, or subsidise, professional 'help'.

It is a fallacy to believe that this sort of tax-financed professional

'help' stands outside capitalism; that it is in some way a still pool in the middle of a raging river. This belief is encouraged by funding agencies who make an unargued distinction between 'commercial' and 'uncommercial' work. They demand that projects which are revenue funded do not show a 'profit'. Every year, the income of such a project is required to be marginally less than its expenditure. If the loss is too large, the group is liable to be condemned as imprudent or badly managed. If the income is larger than the expenditure, however, then the 'profit' is liable to be deducted from the following year's grant; and the project will be regarded unfavourably for asking for more money than it 'needed'.

Community artists are encouraged to feel that they are not working in the market place, and the grants that they receive serve to remove them, and protect them, from a market place within which they would be unable to survive. This is a gross simplification, and a cruel deception. Every year we compete for the attention of the funding bodies, who are our patrons, and also our primary customers. We produce lavish annual reports, and exhibitions of work done, which we 'sell' to the funding agencies; the asking 'price' being the following year's grant. The communities with whom we work are not really our customers, since an increase in their support and enthusiasm will not necessarily increase our grant, just as a decrease in their interest will not necessarily decrease our grant. In institutional terms, they are our 'clients', and what that really means is that they are the raw material upon which we work, on behalf of our customers, who are the agencies to whom we sell the reports and documentary evidence of our work.

We may try to persuade ourselves that this is not so; that our revenue funding enables us to work with tenants' associations and neighbourhood groups to wrest more money from the state, but we are fooling ourselves. Every increase in the price paid by a funding agency for the annual report, and schedule of forthcoming work, from one group is a decrease in the amount of money available to be paid to other such groups. This is definitely a market economy, albeit a specialised and quite idiosyncratic one. It may be a small and cosy market, in which we know most or all of the people involved, buyers and sellers, but it is as cruel as the capitalist market place, for it is in fact a sub-division of it.

This addiction to revenue funding, and the lobbying needed to keep the dosage increasing, has blinded us to our own strengths, and the potential of other methods of organising. It has confined us to the kind of marginality that we would have rightly scorned had we observed it elsewhere. We can no longer afford to be blind if we wish to construct a rational programme. We must look to other methods of organising; methods which acknowledge from the start that money can never be

neutral under capitalism. We must keep economic relationships transparent and direct, and they must be part of the debate that occurs within, and about, resources.

We must build *common organisations*: legal forms of association which are rigorous in their approach to money. I am using the word *common* here as a deliberate reference to the historical rights of English people to have unimpeded access to the commons, which in principle can belong to no one individual, but are owned by all. I am also using it to refer to those acts which serve to bind people together, or make them more aware of how they are, or how they might be, bound together in community. These common organisations must be rigorous about developing a *transparent economy*, which is readily and openly debated. In a transparent economy, not only is the amount of income and expenditure visible, and comprehensible, but most importantly, the line of supply of the income is visible and comprehensible. Members of an organisation with a transparent economy can not only find how much money that organisation has; they can also find out where it came from, how it arrived, and what conditions were attached to it. Such common organisations can be used to amass social capital, and to build competence within the process of community.

Not all forms of legal association will be equally suitable for common organisations engaged in cultural production. It may be, for example, that such groups would wish to be cooperatives or partnerships, rather than operating under the authoritarian whimsy with which the Charity Commissioners seem to rule.[4] The very notion of charities is enmeshed in Victorian concerns with helping designated categories of the deserving poor, not only in the connotations it evokes but in the range of legal structures which are acceptable to the Charity Commissioners. Charities cannot be run by those who work for them, except by sleight of hand, and the trustees must be acceptable to the Commissioners. They must not engage in political activity, and the decision as to what is, and what is not, political activity rests, in the final analysis, with the Commissioners. They are tailor-made for organisations which are representative of a wide constituency, to whom they are responsible. They are considerably less suitable for the purposes of activists who wish to work *with* groups of people to build community and foster competence, and who wish to be responsible for their own actions, as the people with whom they work are responsible for theirs.

If the legal structure of an organisation will affect the way it thinks of itself, and therefore the way it works, so will the funding it receives, and the way in which it receives it. Common organisations must take steps to determine their own funding patterns, by proposing strategies

which would remove them altogether from a debilitating addiction to revenue funding. They must replace these with patterns of income which will advance their overall aim of propagating cultural democracy. I will suggest ways in which this might be done later.

We must fight to build organisations which are positive in their commonality, and not merely responsive to whatever the latest threat happens to be. If we are merely responsive, then we will deal only with the symptoms, and never with the underlying causes. Cultural democracy will emerge, not as the by-product of daydreaming, but as a result of practical programmes, and strategies for giving effect to these programmes. These programmes will determine which groups we work with, what work we do, and what we do with this work once it has been completed. Only if our work is planned in this way, rather than by those whom we are, in one way or another, opposing, will its effects be durable and cumulative.

Chapter Sixteen

Work practices

Community artists, like community workers, have been taken under
the wing of the state and cooped up in cages where they can make a lot
of noise without harming the interests of the state. Their work still
contains an element of what was once referred to as 'soft policing',
which the state can enlarge and build upon. Community arts practice
can be seen as a symbolic concern for the plight of the oppressed
which can be touted as though it *were* a real commitment. Thus the
funding of community arts can be used as a kind of social sticking
plaster; where there is a riot the money is found for a mural and the
problem of the quality of life in the area is deemed to have been
addressed. By funding community artists and community workers in
this way in areas of deprivation and social strife, trouble is kept
simmering at a manageable level; never cooling off entirely but never
reaching boiling point.

This has happened because community arts, as a movement and as
a set of developing working practices, has been exceedingly malleable
because it has never owned up to its aims nor ever defined its
practices, for fear of losing some of its fellow travellers. This fear
should be, at most, a minor worry. If we are to unite around our
strengths rather than around our fears we must examine our working
practices and relate them to our aims and our organisational forms.

It has frequently been stated that community arts is an approach to
the arts, rather than a specific art form in its own right. In this vein,
Yorkshire Arts Association's *Community Arts Policy Paper* states
that 'the label community arts is not used to refer to one particular
technique or type of finished product but to an attitude towards the
relationship of the artist and the arts with society'. In the views it
expresses, this paper is clearly a descendent of the Baldry Report. It
is, in fact, possible to go much further than this, and to be much more
specific. It is possible to delineate two different but complementary
activities, with characteristically different working practices, sharing
this 'attitude', and thus both recognised by the funding agencies as
community arts. Each seek, however, to develop in different ways and
to serve different needs.

The first kind of activity is based upon the notion that people have a
right of access to the means of communication within society, and the

right to acquire the skills necessary to use these means of communication. The assumption behind this approach is that the ability to communicate, and thus to make oneself known, is fundamental to any society professing to be democratic, and that people should therefore have a democratic right of access to appropriate tools of expression such as screen-printing equipment, photographic darkrooms and offset litho printing. These tools are expensive, time-consuming or space-consuming to an extent which places them out of reach of all but the leisured and wealthy. Because of this there is a need for *resource centres* which will effectively hold this equipment in trust for their users, who will then be able to use it as often as they need to or want to, without worrying about how much it is costing them to own or rent it all the time they are *not* using it. The ownership of the equipment is socialised and becomes a community asset rather than an individual burden.

In many respects the impetus behind this work parallels the drive of Working Men's Associations in the nineteenth century to establish popular libraries, in the realisation that literacy was a prerequisite for any participation in political activism. It shares with this movement the realisation that some things have their use-value maximised when their ownership is, in one way or another, social. A hundred people each able to afford one hardback book will do better to join together to form a pool of 100 books from which they can each draw. Similarly five groups wishing to use a printing press one day a week will benefit from sharing a single press and pooling the money thus saved to pay for a worker to assist them and maintain the machine. Arguably, the need for resource centres is as great today as the need for libraries for it is the capital cost of a word processor or printing press which is beyond the capacity of individual working people today, and not the cost of a paperback book. This kind of community arts work aims to serve the needs for expression and communication which people already have, and which they already know they have. Its concern is with the *defensive actions* of community, and for the provision of those tools, services and teaching without which the maintenance of that growth would be impossible. Its work is geographically bound, and strongest where its geographical roots are deepest.

The second kind of activity is based upon the notion of *co-authorship*, through which people with different skills and different levels of skill can come together as a team to work on an activity which they will jointly author. This kind of work is concerned primarily with the *expansive actions* of community and will work not only on the techniques of printing or photography or whatever, but also on developing shared understandings of the content, context and subsequent use of the images produced. Here community artists

cannot remain neutral; they cannot merely assist people and maintain the machines. Instead they must function as members of a team and their own judgements and opinions will form as much a part of their contribution to the team as their repertoire of technical skills.

The process of *co-authorship* is at the heart of the working practices of this kind of community arts, as well as being its particular contribution to the historical process of cultural activism. One very important strand in the history of community arts has been the steady development of techniques through which *co-authorship* may be fostered in a way that leads to what the Minister for the Arts might recognise as 'professional' results. These techniques started within those thematic community festivals which were structured so that they provided a framework within which everybody's contribution could be accommodated and made comprehensible. In these festivals it was often the creation of the framework itself that was the community artists' specific contribution. It enabled activities to be coordinated in such a way that the Festival was more than the sum of its parts and an act of creation by *all* those who participated.

Since then these techniques have developed into more shophisticated processes capable of sustaining more complex and detailed work over a longer period of time. Often the techniques involve carefully constructed devising sessions, planning meetings or games workshops in which the skills of the community artists are directed towards creating situations out of which collective feelings and decisions can arise. From these a set of aims, goals and targets can be agreed and the process of constructing a programme can begin. As the programme is undertaken the cycle may begin again and again, concentrating each time on a more specific aspect. For example, a tenants association may approach a community arts group because they have just formed and they wish to publicise their existence. The initial devising sessions may look at the many different ways in which publicity can be achieved and the various costs and consequences of each method. Out of this may come a decision to declare two specific campaigns as the group's target for its first year, and to make them successful through a programme of monthly newsletters and quarterly poster campaigns culminating in two public meetings. The cycle may then be repeated again with more detailed devising sessions which look at the ways posters can be used, and which produce a detailed set of aims for the posters and a programme of workshops to produce them.

This kind of work is necessarily interventionist and selective since, if it is to be successful, it must involve the formation of groups, of however temporary a nature, which can become teams and work together towards agreed goals. Unlike that community arts work

which is concerned with the provision of 'open access' resource centres it does not just concern itself with teaching people what they need to know in order to do what they want to do, but is instead directly involved in exploratory work through which people can discover what it is they *do* want to do. Community artists working in this kind of practice must make choices about the groups with which they will work, and develop policies and agreed criteria as to how these choices will be made.

These choices must be made as part of a wider strategy and cannot simply be left to accident or sentiment. If we are to build upon our work, then that work must itself be cumulative, and the individual projects upon which we work must also be capable of being seen as concrete examples of powerful and widely applicable ideas. We have tended in the past to work with the most powerless groups in society (the institutionalised; the old and the handicapped) and to use their powerlessness as the justification for our work with them. This kind of intervention is perhaps justifiable on humanitarian grounds, but it is usually patronising and worthy; treating the institutionalised as patients and as unfortunates with deficiencies which they can be helped to come to terms with. This kind of work does nothing to challenge the position in which the institutionalised find themselves. At best it helps them find some individual happiness by giving them things to do within the institution which are perhaps less boring than the things they might otherwise be called on to do.

If our work is to be cumulative we must work with these groups, and with many other groups, in a completely different way. Our projects must place the experiences of those with whom we work in wider contexts so that they connect together to become a visible block and a potential force. These experiences can then challenge the dominant ideology by insisting that the disadvantaged are more properly seen as the disenfranchised. To achieve this we must link our working practices and our theoretical analyses in a way which we have so far resisted. Each practical project should proceed from, and test, a set of assumptions which can be developed or changed in the light of experience. Each project should be a practical example of a wider theory, just as each theory should be drawn from the conclusions we reach from our practical experience.

The working practices of community artists are avowedly radical, and yet we have shown little real interest in the ways our practices actually work and the effects they do, or might, have. We have fallen into a shallow type of 'common sense' which has meant that the effects of our work have often been the opposite of what we would have wished. This has not been true of all community artists, some of whom have a deep understanding of the meanings of their work, but the

movement has failed to draw from these individual experiences, and
so they have remained both individual and isolated. We have not, in
the main, taken our interest in our practices much beyond a concern
with their surfaces, with their immediate content.

Community photography, for example, has often followed in the
footsteps of the socially concerned documentary photographers, who
have aimed to use photography as a means of stimulating change. This
form of practice, with its depictions of the unemployed, of inadequate
housing, of badly fed children, is riddled with contradictions. In order
to help people it depicts them as helpless victims of circumstance and
in order to liberate people it makes public images of their degradation.
This kind of photographic practice almost always amounts to cultural
missionary work, in which the poor or the unemployed are depicted as
a bewildered under-class who can only be helped by the intervention
of concerned third parties. It arouses the kinds of feelings in the
spectator which John Berger has described in relation to the war
photographs of Don McCullin. 'The most extreme examples — as in
most of McCullin's work — show moments of agony in order to extort
the maximum concern. Such moments, whether photographed or not,
are discontinuous with all other moments. They exist by themselves.
But the reader who has been arrested by the photograph may tend to
feel this discontinuity as his own personal moral inadequacy. And as
soon as this happens even his sense of shock is dispersed; his own
moral inadequacies may now shock him as much as the crimes
committed in the war. Either he shrugs off this sense of inadequacy as
being only too familiar, or he thinks of performing a kind penance — of
which the purest example would be to make a contribution to Oxfam
or Unicef.'[5]

It is possible then for the deeper layers of meaning in a photograph
to work in contradiction to its apparent content. This is likely
wherever the modes of production and reception of the image have
been ignored, or dismissed as secondary to the message contained in
the 'content'. Moreover this is as true of murals or posters or festivals
as it is of photographs. It is not enough, then, to attempt to use modes
of artistic production in a 'radical' way; the possibility must be faced
that there are some modes which, in their very structure, are
unsuitable for any community arts programme.

An example is provided by the large, outdoor murals which have
always been a prominent feature of community arts. Many have been
seemingly undertaken with little thought for their long term effects,
and yet they are among the most enduring images produced by
community artists. Murals come in three sorts, although the
distinctions can, in practice, become blurred. Firstly there are those
painted in enclosed or 'private' spaces, which are intended for a

specific and known audience. These both celebrate, and are part of, a social process in which those who view the mural are as much participants as those who painted it. They are usually seen only by those who have a direct connection with the space in which they are situated, and they become a part of the collective history of a particular group of people. Like a holiday snapshot, or a group photograph, this kind of mural can act as a marker for the memories which surround the process of its creation and the image it depicts. The meanings that accrue to it form a *primary understanding* for they will be part of a body of collective knowledge, and stepping stones towards community.

Secondly there are murals painted on the outside of buildings such as tenants association halls, youth clubs and community centres. These form both a statement of group identity and a form of self-advertisement; a personalisation by the group of an otherwise anonymous building. The design and painting of the mural becomes an attempt to articulate a common experience and forge a common language. The mural serves as a point of clarification about what the building is, how it is seen by those who use it, and how they invite other people to see it. It provides one source from which those passing may derive their knowledge and opinion of the building and those who use it. Both these sorts of murals are subject to a process of dating at two levels. They deteriorate physically over a period of time, and the images gradually become less relevant as the membership of the group changes or its activities develop. Where no account of this is taken when a mural is planned the result can be the kind of environmental blight that the mural was originally intended to alleviate — fading, half-forgotten images like graffiti written by a giant. Where account *is* taken of this, the results are often powerful, effective and enriching.

Thirdly, there is a large group of murals painted on 'public spaces'. These may relate in a very general way to the area in which they are located, but they are unlikely to be related to the building or wall on which they are painted, and will usually have no contextual relationship to it. Rather their siting is determined by the location of public spaces that are deemed to be available. These murals may contain images which, in their content, are supposed to be radical: they may be anti-nuclear murals, such as have been sponsored by the GLC on five inner-city sites in London, or they may be images of oppression or of jollity. They do not however respond *specifically* to their immediate environment or the people who live in it, and they could be repainted elsewhere without losing any of their meaning. They are a (radical) message to the world at large addressed by an individual or a small group to an anonymous mass audience. They would make as much, or more, sense printed as posters on large

advertisement hoardings and used as the basis for an alternative advertising campaign.

Such murals do not provide a focal point for a group, nor an emblem for a community; they simply oppress people. They are ideological advertisements rendered more permanent than any capitalists would dare render their advertisements, and they oppress in precisely the same way as any other advertisement. They demand attention from the passer-by in a way which brooks no argument, and they shout their messages at a volume which makes reception compulsory to all but the blind, and acts as a form of ideological conscription. On the surface these murals may be anti-nuclear, or whatever, but like all advertisements, like sexshop windows and displays of pornography, they have an underlying message, a sub-text, which is oppressive and demeaning. On the surface the messages of these murals may be different, but their underlying message is the same. They are a part of a pattern of distribution and enforced reception in which those who receive the messages are given no control over what they receive and no chance to opt out. Moreover they are given no chance to transmit messages of their own, and by being denied this chance they are clearly shown that they are valued only as passive receivers, as consumers.

The sub-text of the third kind of mural is a celebration of the domination of the local state over its subjects. It says: we are powerful and you are not; we are active and you are passive. It says: we can change the very environment in which you are caused to live, and our power is so great that we can use it whimsically. It is the celebration by those in power (who can grant or refuse planning permission and provide or withdraw grants) of their enforced monopoly of decision-making, and it serves to remind those who trudge past how little control they really have over their lives. Moreover it is the public imposition of an ideological view by those in power, *as an example of that power*, equivalent to the celebration of empire to be seen in the many public statues in British cities, only all the more insidious for being disguised as a message of radical and liberating intent.

These murals are proof, if proof were needed, that radical intention is not enough. They say, in effect: *we* will make *your* statement for you on *their* terms. Work which fails in this way to challenge the problems which arise from the structure of our social organisations, *at the level at which they occur*, and which contents itself with dealing with the various consequences of those structural problems, will simply work against itself. In trying to do things for people, it will become another means of convincing people that they cannot do anything for themselves. Walls are not canvasses, and it is an act of banal arrogance to pretend that they are. The result of this pretence is the

kind of visual information which neither leads to knowledge nor accumulates into the kind of understanding which can be acted upon, but remains fragmented and bewildering.

Our work practices must themselves be the subject of debate and analysis, not in order that we can destroy our work, but in order that we can build a practice which is congruent with our aims and which is not self-contradictory. The artistic forms which we carry within our work, and the technology which we use to do it, have been designed and developed to fulfil a set of functions within the high-intensity market that is advanced capitalism. We must be vigilant in regard to the hidden biases of the technical processes we use, and we must be prepared to change these processes and the art forms within which we use them; to mutate them until they better suit our purposes.

The danger that faces a work practice that remains unanalysed is that it rests upon the charisma of those practising it. This charisma need not be a personal charisma; it can be derived from many sources, including the status of the role of 'artist'. So we can find ourselves explaining that we run workshops this way because this is the way we run them; a 'justification' which depends on people acknowledging that we know best because we are paid to do it and they are not. Where this happens the activities of the community arts group will serve to confirm *their* superiority, and the inferiority of their 'clients', and thus achieve the opposite of what is intended. If the practice of community artists is to be radical in anything more than its intentions, it must have working practices which are rooted in the knowledge that production, distribution, reception and consumption are inseparable parts of a larger process, and it is this process in its entirety which community artists must address. Our working practices must include an analysis of the productive processes we use, but these must at all times be related to the processes of reception and distribution.

Chapter Seventeen

Distribution and reception

Public images, which are distributed simultaneously to an anonymous mass audience, act as a bridge between the worlds in which people live and the World which is described in newspapers, magazines and advertisements. They appear as representations of that World, whereas in fact they are disguised expressions of a particular view of it. That view is one which encourages a 'democracy' based upon a spurious freedom to choose between pre-packaged options, and seeks to deny the possibility of meaningful action. These public images do not have this effect because they are cleverly designed, although many of them are. They succeed because of the context in which they are presented, and received, and the methods through which they are distributed.

The relationship between image and reality is inevitably complex, but we can be certain that the image is something that a spectator decodes, or interprets, rather than simply 'sees'. If we wish our practices to amount to anything more than an instinctive 'self-expression', we must incorporate within them an anticipation of the way that our work will be received by spectators. This is not a plea for populism; nor for a consistently high standard of output. It is an insistence that we recognise that the way that a work, or action, is produced and distributed, and the context within which this happens, will limit the ways in which it is likely to be received, and the kinds of understanding which it will be capable of generating.

We cannot simply take the channels of distribution that we find, and try to bend them to our own purposes, as though they were natural phenomena like rivers which we could dam or divert. These channels serve, and are themselves part of, those agencies whose effect is to manufacture the fragmented consciousness necessary for un-questioning consumption. They have also developed their own histories, with their own historical imperatives which may be unrelated to the needs and desires of those whom they are allegedly serving; and which may be related only to their own economics and organisational priorities.

This was illustrated at a conference on racism within London arts centres, held in the summer of 1983.[6] One of the discussions there centred around the explicit, and implicit, racism in the publicity

material which arts centres produced. There were few examples of deliberate, or explicit, racism; but Fay Rodrigues, from the Minority Arts Advisory Service, argued that the racism that *was* present was all the more insidious for being buried within the design of the posters and leaflets. Many of these had designs based around line drawings or cartoons, and in these black people were portrayed in one of two ways. They were either drawn as white people, and then shaded in afterwards with crosshatching or Letratone; or they were drawn as stereotyped golliwog-like caricatures. Both of these portrayals caused deep offence to the black people present, which in turn wounded the white arts administrators present, who were trying their hardest to avoid offending anybody.

The problem with the cartoons was not, however, a problem of racist intentions or attitudes, and could not be solved by simply exhorting the designers to try harder, or to think more deeply. The problem was to do with a form of production and distribution which developed as a part of imperialism, and which carries the assumptions of imperialism within it. This form simply cannot be turned around and fired in the opposite direction; it cannot be harnessed in the service of genuine multi-culturalism.

These cartoons have a range of styles, but they all share a common history, which is connected to the development of mass circulation periodicals and newspapers. The technology necessary for the production and distribution of newspapers on a large scale was developed in the last quarter of the nineteenth century, and came into force between 1880 and 1920. This technology inevitably contained certain technical biases, one of which was a bias towards simple, bold illustrations. The printing processes were not readily suitable for the production of subtle, finely shaded, or very detailed, images and this affected the kinds of photographs and drawings that were produced and used. The cartoons became more and more simplified, using broad strokes and simple stereotypes. A form of cartooning developed which suggested shapes by simply drawing their outline, in the way that children do. A face became a circle, with a few simple features. This happened because the subjects of the cartoons were, almost without exception, white, and so skin colour was not a variable that the cartoonist was required to consider. Indeed, since this was the period of the imperial climax, there were explicit ideological benefits to be gained from a system of cartooning which was only able to reproduce black people in ways which made them into figures of fun. The very way that they were portrayed made them visual outsiders.

Because this form of cartooning received mass distribution, it became what most people meant by cartooning, since it was the only form that most people saw. It became a part of the growing

information industry, and developed its own history. What it could not do, however, was shake off its inbuilt limitations, which included the fact that within the visual grammar which it had constructed people are *always* read as white, unless the cartoonist does something *extra* to them, to indicate that they have an 'unusual' skin colour. This is an inherent limitation, and no amount of good intentions, or Letratone, will overcome it.

The technological limitations of production and distribution which brought this form of cartooning into being have long been surpassed, but the cartooning remains. Like many art forms, and many social arrangements, it is now impelled forward by the force of its own history. Because it has become what people mean by cartooning, it is perpetuated long after the reasons for its development have passed. It has become a familiar form, and its very familiarity serves to justify it. This form of cartooning stands in a stark contrast to other possible methods of representation, in which, for example, human beings are delineated by shading. Here, what is important is the way that light strikes the contours of the face, and what is depicted is the shadows that fall where the light does not reach. In this kind of representation it is possible to show black people and white people in the same manner, and to the disadvantage of neither. In concentrating on light and shade, rather than on the outline of the face, everybody is represented in an equal manner, since everyone's face, whether black or white, will contain both light and shade. This point was clearly illustrated by a series of African posters which Fay Rodrigues showed the conference, which had been drawn by a process of shading, and which clearly depicted dignified white people *and* dignified black people. The contrast between these, and the Eurocentric crosshatched cartoons, clearly revealed the imperialist assumptions that lay beneath the latter.

This form of cartooning came into being because of the need to produce images which could be distributed in a particular and profitable way, but it came to seem the 'natural' way to produce cartoons. Today it is perceived by many people, rightly, as racist, but this is usually in relation to specific cartoons which are said to have gone too far. Because this form now seems a 'natural' way to draw people, the real nature of the problem remains hidden. Distribution is not something which occurs after production; rather they are two parts of a larger single process, and they act upon, and constrain, each other. The developments in production processes which brought this form of cartooning into being were themselves connected to the perceived possibilities of mass distribution, and the profits that could be made through mass distribution.

Mass marketing, in which the products are designed to be dis-

tributed for a large and simultaneous reception, serves the interests of the high-intensity market, and we fool ourselves if we imagine that we can use this system to subvert it. The subversion, like the famous posters of Che Guevara, becomes only another item for consumption, albeit of a deliciously rebellious kind. Mass marketing works by producing a very wide, but fragmented, reception in which phenomena arrive, apparently from nowhere, are given a particular kind of attention, and then disappear into a vacuum. Everything becomes replacable, and everything becomes replaced. Cumulative histories become academicism: kindly forget about the Bay City Rollers because we have Kajagoogoo lined up. Instead of any cumulative history, we have a fragmented present which consists, in part, of 'golden oldies' and occasional Bay City Rollers 'reunions'.[7]

We must aim, in contrast, for distribution which is deep rather than wide, and which builds outwards from an experiential centre, in which people can make active choices. A system of distribution which is narrow, but which penetrates deeply into the community it serves, can act as a focus for communal strength, and particularly for that strength which leads to the development of community self-image and definition. This will certainly not happen if we waste our time trying to infiltrate, or divert, the present mass media, whether we do this by appearing on Channel Four, or by trying to appear on Capital Radio.

Reciprocity must be built into all the systems of distribution which we create. It must be possible for someone receiving an image, idea or message to respond in kind, and to have access to the tools that they would need to respond in this way. This is the practical realisation of the idea of equality of access to the means of cultural input; for it is the systems of distribution which will determine what input is possible, and which people will be able to make that input. Without reciprocity there can be no cultural democracy.

This imposes a particular set of restraints upon the methods of production and distribution that we can use; restraints which are of a different order from those we might seek to impose on the activities of capitalist productive forces. We must use the lowest level of technology possible to accomplish a task efficiently. I do not suggest this for Luddite, or romantic, reasons, but for reasons of economics. The centralised information industry is organised in such a way that its entry costs are prohibitive to all but millionaires and large corporations. A high value is placed upon use of the latest technology, and upon regular innovation, so that these become their own justification, and are hardly related at all to any obvious inadequacies in the technology they replace. There is no logical limit to this kind of innovation, and it benefits those producers who would keep others from entering their domain much more than it benefits the consumers.

Most importantly, it keeps consumers from becoming producers and directors of what they consume.

We must distinguish between technology which is *open*, in that it is capable of being used in many different ways, and for many different ends, and technology which is *closed*, in that it is manufactured to be used in one way for one task. The manufacturer and distribution of pop records is an example of a closed technological system, in which a high degree of capitalisation is necessary. A large quantity of any record must be produced for the production to be economically viable, and the consumer can make only one predetermined use of the record. The manufacture of cassette tapes, on the other hand, is a much more open system, in that the duplication of tapes requires only two tape recorders, tapes can be duplicated in any amount, large or small, and tapes, once purchased, can be erased and re-recorded.

The advent of four track recording equipment, which operates with standard cassettes and which cost less than £600, means that it is possible to produce, duplicate and distribute original music without the degree of high capitalisation required to produce a record.[8] This requires that we accept a limit to technological innovation, and that this limit is, in practice, acceptable. This should easily be possible, for the current Portastudios are capable of providing at least the sound quality of those records produced during the 1950s and early 1960s. Moreover, *Sergeant Pepper*, was only recorded on two four track machines which were linked together. It is only in the last ten years that 24 and 32 track studios have become commonplace.

Closed technological systems have the effect of creating new, and scarce resources, which can be controlled and administered for profit; whereas open systems will tend to promote use values and unregulated activity. 'Studio time' is a scarce resource which is created by the fact that people are persuaded that 'only the best will do', and are then persuaded to accept that the newest and most innovative, the 'state of the art', is necessarily the 'best'. Since, by definition, not everything can be the 'most innovative', any system which makes innovative its primary value will always have scarce resources which are in demand, and which are in demand because they are scarce. Access to these resources will become one of the badges of 'success'.

The large scale use of Portastudios, on the other hand, decentralises the production and distribution of music, at the cost of a standard of reproduction which is 'only' as good as that employed by commercial record companies in the 1960s. It means that people can record music because they want to, with known listeners in mind, and without worrying about its appeal to an unknown, and unknowable, mass audience. In this way, musicians can sell 'professional' sounding tapes at local gigs, and contribute to local cultures, without having to

first 'make it' in the World of newspapers and magazines.

Whether this music is received as 'real' music, or whether it is received as a substandard substitute for the 'real' thing, will not be a matter of accident, and nor will it depend on the music itself, which (like the music the centralised recording industry produces and promotes) will vary from the exciting to the excruciating. It will depend on the contexts which are created for its distribution, and the assumptions and views which prevail at its reception. These are as much areas of concern for community artists as the more traditional areas of artistic production, and they require as much work and as much skill. The problems of distribution and reception are as crucial to the establishment of cultural democracy as the problems of production.

The creation of contexts within which decentralised cultural production can be favourably received, requires us to engage in a wider ideological battle than the battles we habitually engage in. We must create projects in such a way that they become examples of much larger assumptions and much wider ideas; and we must disseminate both these ideas and the examples that make them real. A fireshow might be an unrepeatable event, which cannot be distributed, but the ideas behind it, and the pleasures and benefits it created, can *and must* be documented and distributed. We cannot 'sell' specifically local events nationally, but if we cannot find some way to get them on the 'national agenda' we will be reduced to acting out a sentimental parochialism. We must therefore 'sell' nationally the idea that local events are more important than national events, and that the national culture should be viewed as a federation of many cultures, each dominant within the community from which it arises, rather than as a central powerhouse with small, regional branch offices. We should produce, and distribute, histories of our work, which are themselves open rather than closed. These histories should aim to place events in the kinds of contexts which enable viewers, listeners or readers to understand why the events described occurred, what they achieved, and *how they could be emulated*. In this way we can work in relatively narrow areas, in considerable depth, and yet avoid the pitfalls of parochialism and accidental separatism.

This is not, in itself, a novel suggestion, and many community artists have already done such work. Few, however, with the possible exception of the Social Arts Trust, have made it a central feature of their work, and the community arts movement as a whole has never attempted to coordinate this work into anything approaching the cultural campaign which will be necessary if we are to begin to tackle the related problems of reception and distribution.[9] These are problems of context, and as such they cannot be tackled in isolation

from the other contextual problems which affect our work. Paramount among these problems are the interlocking questions of who controls our work, and whose ends it serves. We can begin to tackle these problems by creating common organisations whose purposes and methods are transparent and easily understood. We will not overcome them, however, until we have developed a programme which takes account of the funding of community arts, and seeks to take control of it; a programme which aims to create patterns of income which will advance our overall aim of propagating cultural democracy.

Alternative incomes

If we want to establish common organisations, we need to look at the ways in which community arts has been funded, and realise that it makes no sense to be a salaried cultural revolutionary, funded, on an annual basis, by the very centralised, and centralising, state whose domination we are opposing. It has been argued by numerous community artists that, however contradictory this position may appear theoretically, we have no practical alternative. The people with whom we work are usually among the poorest, or most oppressed; and they could least afford to pay for our services, and are therefore most reliant on the provision of 'free' services.

Much of this poverty, though by no means all, is that kind of relative poverty which has, in the words of Jeremy Seabrook, become 'an aspect of an economic system, and can therefore never be eliminated'. To use relative poverty as an explanation of a hypothetical inability on the part of the working classes to achieve competence is to abandon hope for ever. Relative poverty will continue to exist as long as people allow themselves to be defined as relatively poor, and as long as they feel this definition to be true. It is also a source of self-justication and self-delusion for community artists, since it allows us to avoid considering the possibility that the real reason that people will not pay for our services is that they do not want them sufficiently, or do not think that they are worth what we would charge. This self-delusion enables us to avoid considering that they might be right in their assessment.

In fact, the workers who organised themselves into the first trade unions, with money that they raised themselves, were incomparably poorer, in absolute terms, than even the long-term unemployed are today. Relative poverty is a concept which effectively masks this historical truth, and discourages people from acting on its consequences. Ken Worpole has written that, 100 years ago, 'although standards of living were much lower, it was possible for some working class people to make real choices about what they wanted to do with money left over from securing the material necessities: buy shares in a newly formed local co-op; subscribe towards the building of a local political/cultural centre; make regular payments to and help manage the local lodge of a friendly society; and

before the imposition of compulsory state education in 1870, subscribe towards an informal "penny school" for one's own children'.[10] What they were doing, in many different ways and with many different degrees of success, was building social capital which existed under the control of the communities in which they played active roles.

To try to achieve social change from within the state, out of fear that people would not be able to achieve it in any other way, is to misunderstand the economic system, and to attempt the self-contradictory. It is to try for change without commitment; to try to achieve a revolution in which the social change is consumed like any other industrial output. No cause, however deserving, can be achieved through passive consumption, for no revolution is ever a spectator sport. Social change arises from material struggles, and from the active processes that are involved in struggle. These processes require commitment from those who participate in their development, for they require time and money. Any commitment made within the social relationships encompassed by capitalism must include, and be in part legitimised by, an explicit or implicit financial commitment. When this commitment is made apparently unnecessary, because of the provision of 'free' state-directed services, then the process of legitimation becomes a legitimation of the state, and the dominant economic system.

Raising funds collectively to pay for a community resource or activity can be a crucial means of raising the consciousness of those participating. State funding renders the line of supply of community resources opaque, and apparently neutral. Activity in the print room is demystified at the expense of mystifying the supply of printing presses. Raising funds for a project must be seen as a vital part of community activity, and not as a separate and preceding chore. Only where the raising of funds for an activity is clearly seen as a part of that activity, subject to the same criteria of acceptability and accountability as every other part, can the supply of the activity, and the resources that are necessary for it, be truly open to demystification. Only when this occurs will an overall increase in dependency be avoided.

I am not arguing that people ought, in any simplistic way, to be made to 'pay for what they get', on some sort of payment-by-treatment basis. This is not a monetarist argument. There are many other ways in which communities can begin to amass social capital, and become a force — an 'estate' which can enter into partnerships with the state — which are equitable, rather than relationships with the state in which they become 'clients' and supplicants. Indeed, the almost total submergence of other models of social organisation is part of a radical

monopoly produced by, and as part of, the industrialisation of consciousness. The claim is insistently made that there are only two viable models: the centrally and professionally organised state welfare system, and the capitalist market place. This is a lie spread in the service of passivity and increased consumption.

Community artists must find ways of carrying forward the forms of organisation that Ken Worpole has described, in the knowledge that what was possible for a working class suffering under a severe, and absolute, poverty must certainly be possible for working people with a considerably larger disposable income, whose poverty is relative. Ken Worpole goes on to argue that, from this perspective at least, the pre-school playgroup movement has been one of the most politicising movements to be found in working class area in the last ten years.

'This may seem bizarre since everybody knows that in origin it was a middleclass, voluntaristic form of childcare provision. And financially playgroups look very much like a market economy form of provision . . . yet in practice playgroups became much more than forms of childcare. They became *forms of association* . . . They often involved a high degree of self-management in which people became used to administrative skills . . . so what looked like a market economy form of provision ended up as embodying the much deeper political forms of *association* and *self-management*. State child care has often provided neither.'

Our methods of organisation, and our methods of raising money, then, must be congruent with our cultural and political goals. Some groups on the political left, like some evangelical religious groups, require their members to *tithe* a percentage of the income to the group, both as a method of building an autonomous political base, and as a method of demonstrating a level of commitment to the aims of the group. Community artists have been unable to organise in this way, because the pragmatism of the movement has left us unable to explain how the alleged aims of our work relate to its day to day practice. We must construct a programme which enables us to make this connection, in order that we too can develop forms of association, and methods of raising income, which allow our supporters to participate in the control and maintenance of the resources that result from their contributions. This will be a different form of community control, in which the process of tithing serves to forge community, and to foster competence, through encouraging people to maintain control over what they have themselves helped to create.

The process of tithing can take many forms, and is itself only one

example of an alternative approach to funding. It would be possible, for example, to organise in a similar way to the original friendly societies and trade unions: for everybody to give a small weekly sum, regardless of whether or not they had made use of the resources that week. It would be possible to amalgamate a community arts resource with an already 'profitable' enterprise, so that the one paid for the other. AlphaBet, in the Blacon district of Chester, is in some ways an example of this approach. A group of people there set up a bookmakers shop, with the specific intention of using the profits that this would generate to pay for a community programme of pensioners' outings, and young people's play facilities. The founders of AlphaBet reasoned that the people in their area *already* spent a percentage of their money gambling, and would continue to do so no matter who owned the local bookmakers. If they opened a shop, however, the money spent on gambling would remain within the community, and the profits could effectively be recycled within the neighbourhood.

There are many additional ways of funding which need to be explored; from a carefully researched use of deed of covenant, to a close analysis of the precise differences, if any, between 'commercial' and 'non-commercial' work. This distinction is often illusory, and the hierarchy of moral worth and strategic priorities which has become attached to it, is largely the result of the policies of the funding agencies. This distinction serves to demarcate, and isolate, community artists, and to hinder the formation of useful alliances. If a local band want to make posters for their new single, this is often seen as 'commercial' work, while a local community publishers making handbills for a collection of local poetry will be deemed 'non-commercial'. A closer analysis, however, might show that both the band and the publishers work collectively, and that both have produced an initial 1000 copies of the work they wish to advertise. The difference between them lies in the way that they have funded their work, and the status that this funding has accorded them. The publishers have a small revenue grant, from a funding agency, while the band fund their activities from their own disposable income. One is viewed as a legitimate community group, while the other is seen as a bunch of self-interested entrepreneurs.

While we are exploring alternative forms of funding, we should, however, remember that grant aid is not *per se* a bad thing, and our acceptance of money from the state does not *automatically* enable the state to incorporate our activities within its own agenda. The problem is not the money itself, but the particular forms that that money takes, and the specific conditions which are usually, in one way or another, attached to it. These conditions range from those

demands that we explicitly accept (such as the provision of audited accounts by specific dates), to those definitions which we are 'encouraged' to adopt (such as the mechanical division of work into 'commercial' and 'non-commercial', regardless of its intent). It is not a question, then, of whether or not we should accept money from the state; but rather, of how we can do it, if indeed we can, without negating our purposes in asking for it.

We can do this by ensuring that any state aid we receive is given to us in ways which assist us, as communities, to attain competence. We must abandon the liberal notion that doing *anything* is better than doing nothing, and must recognise that some actions will take us *away* from our goals. If our financial arrangements are to be subjected to the same criteria as our creative work, then we must understand that some financial arrangements will simply contradict our overall aims. It would be better not to accept these arrangements, even if, as a result, the project could not be financed, and therefore did not take place. The alternative would be a project which *appeared*, on the surface, to fulfil its avowed aims, but which, at a deeper, level contradicted them. We must be prepared to refuse to accept grants which do not meet our requirements, in the knowledge that we shall, as a result, do less, but that what we do in fact do will be far more substantial, and far more capable of having a lasting effect.

As a starting point, for methods of grant aid which are congruent with the growth of competence and community, we must attain a high level of 'multiple funding' for every project in which we are involved. By this, I mean simply that the funding for each project should come from a number of different agencies, rather than from one agency. This multiple funding must include a sizeable proportion of funding raised by, or within, the communities who are participating in the project. Moreover, the funding should be so arranged that, with the exception of the funding raised through community, no single source is of such a size that its withdrawal would halt the work.

Arguably, there is an important exception to this strategy, and therefore to the strategies which follow on from it, and which are detailed below. This concerns those resources and facilities, such as community darkrooms and printshops, which provide neighbourhood services that aim to maintain a protective level of community. Some of these resources may wish to argue that, in a technologically complex society, they occupy the same kind of position, and fulfil a parallel role, to that occupied by public libraries in the early part of this century. They provide the kind of access to tools of communication and 'culture' which, for economic reasons, would be

otherwise available only to the very wealthy, and their disappearance would erode even that small amount of democratic participation which is currently available.

These groups may wish to raise their funds from their users, but they may, on the other hand, argue that the facilities they provide should be made a statutory requirement for local authorities. It is as important for people today to have access to communications equipment, of whatever sort, be it printing or drama, as it was for their grandparents to have access to books. An activity as important to the inhabitants of a borough as these potentially are, should not be dependent on grants which carry no legal commitments, and which are like presents from a kindly uncle. Where this argument leads to the belief that these activities should become statutory responsibilities there will need to be a strong local campaign, linked to a network of such campaigns, to demand that central government amends the Acts of Parliament governing the powers and responsibilities of local authorities, and adds the provision of communications resources to the list of facilities they are legally obliged to provide.[11]

On the other hand, groups providing these facilities may be as wary of being subsumed into the local state as other community arts groups. They may believe that 'municipal socialism' would hinder, rather than help, them. In this case, too, they must argue their case forcefully, and arrange their funding strategically. What they cannot do is try to get the best of both worlds; to try to get the apparent security that comes from being a part of the welfare state without actually being part of it. That is the kind of pragmatism which pays for its short term gains by long term impotence.

The next stage in the construction of an alternative pattern of income must be the conversion of *all* revenue funding to what is currently referred to as project grants. Here specific aspects of a group's work, which are clearly limited in size, scope and duration, are presented to the funding agencies for consideration for a single grant. This sort of application would differ greatly from what most funding agencies currently see fit to regard as suitable candidates for project funding. What I have in mind are not applications limited to events that cost £400 or £4,000, or which last ten days or ten weeks, although these would be included; but rather a different approach to the process of organising work for funding. The present system of revenue grants places community artists on a pseudo-salary, which will continue to last until, for one reason or another, they fail to sell their annual report to their funding agency. At the point of sale, the funding agency considers, and therefore has control over, the overall purposes and direction of the group, and may make certain

'recommendations' to the group as conditions of grant aid. I am suggesting that our ambition should be to achieve a situation where the overall purposes and direction of our groups should remain, at all times, in the hands of the community members and the community artists. Community artists should therefore define their work, both to themselves and to any funding agencies they approach, as a series of finite projects lasting from five hours to five years, but each having a clearly argued starting point and leading, through a comprehensible programme, to an organised finish, from which conclusions can be drawn. Each project may be accepted, or rejected, for funding, but the group itself will not become a pseudo-salaried subsidiary of the funding agency.

To begin this move towards competence, three hurdles must be crossed. Firstly the funding agencies must be made to disperse their funds in this way, through a vocal and well argued campaign, coupled with a refusal to accept grants in any less beneficial form. This we should have insisted upon from the start. Instead, we fell into the liberal fallacy of imagining that we could be accommodated in a newly built room adjacent to the old citadels; that the forms of grant aid which had evolved to deal with the desire to subsidise the heritage arts would be suitable for us. The irony is that they proved more suitable than anyone could have imagined: they turned us into a minor heritage art whose business was compassion, concern and education. We must pressurise the funding agencies into switching to long term project grants, by consistently drafting our applications in this way, and by encouraging all those groups with whom we work to put in applications for our services in this manner, and to pursue those applications vigorously and confidently. We must work in this way to establish a new pattern of funding from the ground up.

Secondly, sufficient income must be generated by the workers and users, through tithing, covenants or 'commercial' work, to cover the residue of unavoidable revenue costs, which may fall into no easy categories. These should be minimal, however, since almost all the standing costs that a group incurs (whether rent, van maintenance or depreciation) can be included, on a proportional basis, as a part of each project application. Thirdly, the workers themselves need to gain sufficient courage, and sufficient belief in the strength of the activities in which they are engaged, to abandon the salaried security of a pre-packaged professional career, and any attempts to achieve that security. This might be easier when it is finally acknowledged that 'job security' based on the receipt of a grant than can be withdrawn at the start of any financial year is, and can only be, illusory. Every attempt to achieve this illusory state, to make it real, only serves to make us that much more dependent on the state.

When we achieve all this, we will cease to be shadows of the funding agencies, and become a solid presence on the political and cultural landscape. Then we can look forward to forging the links that will be necessary to achieve the overall aim of cultural democracy. Then we can begin the vital work of creating networks and alliances.

Chapter Nineteen

Networks and alliances

The aims of community artists will never be achieved as long as their work is based in significantly small pockets of society. For the constant pressure of the dominant structures will erode any gains that are made as fast as, or faster than, they are achieved. Yet if community artists abandon this work, they will pass over the real and potent opportunities that are contained within it. We must, therefore, find ways of linking our different practices, and generalising our successes, while maintaining within each project the control and self-determination which is essential to competence. We must create *networks* which are open and flexible, and yet which build upon the autonomous strengths of the different projects from which they are formed.

These networks need follow no single model. They will vary according to circumstances, and the needs of those involved in them. They may be formal or they may be informal; they may be temporary or they may be permanent. They will all, however, have certain purposes in common. Firstly, they will enable those groups involved in them to pool resources, and to share equipment and technical skills. In this way groups will be able to increase the pool of skills available to them, and reduce their expenditure through bulk buying and joint purchases. Thus a federation of local groups might start a resource centre to service their own needs, and instead of each buying ten reams of paper a month jointly bulk buy 200 reams.

Secondly, such networks should enable groups to share the knowledge that they have gained through their working experiences. They will be able to share and pass on not just the technical skills involved in cultural production, but the approaches to those skills, the attitudes and understandings which guide the application of technical expertise. This will be a reciprocal, and democratically organised, form of training; a mutual education in which there are no trainers and trainees, with distinct and different roles, no centralised curriculum, and no preordained need to meet or surpass certain 'standards'. This kind of training, in which the participants decide what it is that they wish to learn and then devise a structure within which to learn it, should aim to share the methodologies of the community arts practices to which it is related. It should be

concerned with collective understanding, and collective meanings, and should be viewed, not as training *for* the work, but as a particular strand *of* that work. In this respect it will stand in opposition to the growing number of 'community arts' courses springing up in polytechnics and art colleges which seem, in many cases, to share with community artists little more than a basic terminology, the use of which is itself open to dispute.

Thirdly, networks will provide an additional dimension to the work of community arts groups, which will in turn provide a base for future developments. The whole of a network will strengthen its various parts, and those who participate will participate in the building of a movement, rather than in an isolated local event; as each local event comes to be seen as a small step towards the movement.

Fourthly, these networks will provide a new kind of market, in which there is no strictly hierarchical division betwen those who produce and those who consume, but rather a series of interchangeable and interchanging roles. They will be the consumers of what each other produces, but they will also be the producers of what each other consumes. Obviously there is more possibility of these networks functioning easily in some areas than in others; we may be producing music festivals for each other but we are unlikely to be producing each other's washing machines and estate cars. The limitation will not make these networks unimportant however, and nor will it restrict them to the areas of culture. Housing, health, mechanical repairs are all areas which can, and to an extent have, been organised in such networks.

The demand for cultural democracy, around which these networks should unite, is a revolutionary demand. To decentralise the means of cultural production, it will be necessary to overthrow the dominant structures; the determining agencies whose effect is to fragment and bewilder for the sake of increased production. They cannot be reformed because they are *systemically* oppressive, and they cannot be tamed or controlled because their inherent oppressiveness would continue no matter who their nominal masters were. They must be demolished.

If we make this revolutionary demand, then it is incumbent upon us to spell out the kind of revolution we have in mind, and to indicate the role of a cultural movement like community arts within it. During the lengthy period during which capitalism has advanced and developed, it has passed through a number of distinct phases, or shifts, of which the most recent has been that shift leading to what Ivan Illich has termed *radical monopoly*, and the subsequent growth of that organisational form into the areas of ideology and

consciousness. With this shift, capitalism has outgrown its origins as an economic system, and become a *system of living*, which not only produces automobiles but also the desire and necessity for automobiles. Indeed its economic base is now dependent on the production of manufactured desires and necessities, in increasing numbers; for without them it could grow no further, but would stagnate and wither. The systems, structures and organisational forms which have been created to manufacture desires and necessities, to industrialise consciousness, are inherently oppressive. They fragment and bewilder, and oppose all activity which would lead to knowledge and the creation of shared meaning, centred in comprehensible community.

This system cannot be overthrown by actions which take place only in the spheres of economics or politics, because the system is no longer encompassed by these spheres. Actions in these spheres, undertaken in the belief that they are, on their own, revolutionary can only result in reform. What was a genuinely revolutionary demand 60 or 100 years ago has become, through the process of historical change, a reformist demand. Radical monopolies, and the closed technological systems which support them, are oppressive by their very nature, and will continue to be oppressive no matter who owns them; whether it is members of a capitalist ruling class, or a proletarian People's Committee. The point is not to try to change the ownership of Capital Radio; the point is to end a system which creates a scarce product called 'air time', which enables a few people to broadcast to an anonymous mass who are unable to reciprocate. Beyond a certain, fairly trivial, point, it doesn't matter *who* is broadcasting, nor even what they are saying. What matters is abolishing a man-made, and forcefully sustained, radical monopoly.[12] The point is not to change the ownership of the Ford motor company; the point is to stop a system of production in which innovation is a neceesary tool for the production of programmed demand, and is sold as a value in its own right.

I am not saying here that we should not be concerned about what is broadcast on Capital Radio, and nor am I saying that we should not change the ownership of the Ford motor company, should the opportunity arise. What I am saying is that, worthy as these aims might be, they would *necessarily* be reformist, and would *necessarily* leave the dominant social arrangements intact, albeit staffed by a different team in different coloured shirts. This would be the case no matter how 'revolutionary' the language, and no matter how 'radical' the intention. The nationalisation of every unit of production in this country would, on its own, do nothing to change the underlying cultural drives which fuel production, and in

particular the production of that consciousness which is necessary to sustain an ever-increasing consumption.

A revolutionary demand must encompass all aspects of the system it opposes. It must offer an alternative, not just to the wrongs perpetrated by the system it opposes, but to the underlying causes of these wrongs. The demand for cultural democracy is such a demand. It proposes the decentralisation of the means of cultural production, and the abolition of any centralised cultural agenda which can be used to denigrate the pleasures of one group to the advantage of another group. It proposes a struggle to establish the right of equal access to the means of cultural input, and a consequent set of limitations on the industrialisation and capitalisation of cultural output. It proposes networks based around use value, rather than exchange value, and shared productive activity rather than privatised consumption. In this way, it proposes a new material relationship to production, which is capable of democratic control, and which is based on agreed needs decided in transparent debate.

The struggle for cultural democracy is a socialist project aimed at reuniting the spheres of production and consumption which have been torn apart during the development of advanced capitalism. This separation is maintained by cultural force, by the powers of ideology, and we must propose a material alternative to this, in its entirety. We must forge an alliance which covers those allegedly separate areas of production and consumption, and we must recognise that, in an economy dependent upon stimulated demand, the consumer is not without power. Production for profit now depends on consumers agreeing, or being trained to agree, that they will 'need' what is produced. People are not completely determined victims of circumstance, however, and they need not always, and everywhere, agree to 'need' what is provided.

The desire to link together production and consumption, and to frame a demand which encompasses both, is not at all a desire to establish a 'popular front', in which what we believe is diluted for the sake of an apparent numerical strength. That is the road of pragmatism, and I believe that the community arts movement has suffered enough from that already. It is a road which goes nowhere, although it sometimes goes by the scenic route. Nonetheless there are certain alliances which we must forge if we are to avoid the fate which has been planned for us; if we are to avoid becoming the salaried rebels who are excitingly dangerous to watch, but guaranteed not to bite.

We must forge alliances with those who share our goals of cultural democracy, and we must do this in ways which will advance our joint position. We can only hope to be one wing of a much larger

struggle, and we must address ourselves to the question: where are the other wings of this struggle? Some we will find in parts of the labour movement; in the trades unions and trades councils. Some we will find in the green movement, and some we will find in the many consumer movements — from tenants associations, claimants unions and advice centres to Friends of the Earth. We must remember, however, that not everyone in these groups will necessarily share, or even understand, our aims, and that our alliances will be with *people* within these groups, not with the institutions that formally constitute the groups.

Our alliances with these groups of people must be genuine partnerships, in which the aims of both parties are advanced. In our work with trades unions, for example, we should cease pretending that we are, in some way, industrial workers, and acknowledge both our different working circumstances and their relationships to our political goals. We should work on projects which, like the work of the Lucas Aerospace shop stewards, question the purposes of production and the values of what is being produced. It is one thing to step in from time to time to assist campaigns to fight closures or redundancies, but it is another (much more powerful) thing altogether, to also work on projects which aim to produce a critical analysis of what is being produced, and consumed, by the people who are producing it. This kind of partnership aims to politicise those areas of human activity which have been deadened by the process of fragmentation which has gone hand in hand with the development of the high-intensity market. To do this these partnerships should be positive, and forward-looking, not censorious nor longing for a return to some imagined Arcadia. We should be aiming to link cultural and political action, and to locate pleasures which unite production and consumption. The point is not that unionised workers are producing 'bad things', and should feel guilty about it, but that the efforts they are expending could be used to produce *better* things, which could produce more, and less determined, pleasures. The point is not that we once had an active cultural democracy, and it slipped away from us. Rather, we are in a position to achieve cultural democracy, we could have it, and we *should* have it.

It is the much wider struggle which will bring about the collapse of capitalism through the adoption of cultural democracy, and the imposition of limitations on the centralised accumulation of power. This struggle will necessarily have many aspects, and involve many elements. It will involve large numbers of the industrial working class, it will involve many of those engaged in cultural production, and it will involve the increasing numbers of those engaged in organised consumer resistance. It will certainly not stand or fall on

the strength of the community arts movement. Nonetheless, community artists have a real role to play in this struggle. Our particular contribution has been the recognition that there is a process of co-authorship, of collectivity, underlying *all* creative activities, and the development of methods which would enable this collective creativity to be used as a force within society. We have evolved working practices which allow groups of people to come together and participate in the creation of work which will belong to them all, and will reflect their collective hopes and beliefs, and will not be owned by one or two of them. We have created means whereby (admittedly, so far, on a very small scale) people may combine the roles of producers and consumers, enact these roles socially and collectively, and move, as a group, towards competence and community.

The idea of networks and alliances, then, is not something that community artists should regard as separate from our day to day work, for it is at the very heart of our working methods. The ways in which we work with groups, and sometimes help bring groups together, are *all* to do with building networks of one sort and another, and with forging alliances. Indeed, the idea of collective creativity is inextricably linked with the idea of alliances, for at its centre is the belief that people can (and under favourable circumstances *will*) come together to forge permanent or temporary alliances to achieve together what they could not achieve individually. In seeking to forge networks and alliances with other organised groups, as part of a much wider struggle, we are not, then, creating an additional task for ourselves, which we will do as well as our usual work. Rather, we are seeking to take the working methods that we have developed, and use them with a growing number of people, and much wider kinds of group. This is as important a part of our work as the very localised work with which we have more usually concerned ourselves. For if we do not widen the scope of our work, if we do not cross-fertilise it with the work of parallel movements, then we will be restricting ourselves to an increasingly parochial role, of little interest to people other than ourselves.

The role of community artists within this wider struggle is threefold. Firstly, we must engage in projects which explore alternative modes of cultural production, distribution and reception. Secondly, we must maintain a clear analysis of what we have done, and what we are doing, and the ways that it fits into a revolutionary programme aimed at the establishment of cultural democracy. Thirdly, we must persuade others to join with us in a series of widening alliances which can encompass capitalism and its systemic oppressions. We will only be able to undertake these tasks when our

theory, and our practice, and our modes of organisation, are in accord with each other. It is of dubious use, for example, to preach the virtues of cultural democracy while the group to which you belong has a hierarchical structure, and a chain of command which permits movement in only one direction. It just doesn't make sense to tell people that the boss says cultural democracy is good for you.

When we have achieved this accord, when we are ourselves living examples of what we are arguing for, we will have the basis for a programme which will enable us to storm the citadels, and tear them down brick by brick; to demolish the oppressive and imperialist structures and to build in their place a series of smaller haciendas where activity and participation are encouraged and welcomed, and the only activity which is prohibited is the building of citadels.

The haciendas *must* be built.

Notes

Chapter Fourteen
1. Speaking in the film *Dread Beat 'N' Blood*, directed by Franco Rosso.
2. *Elitism versus Populism in the Arts* by Sir Roy Shaw. (John Offord, 1980)
3. Writing in the *Guardian*.

Chapter Fifteen
4. ICOM, the Industrial Common Ownership Movement Ltd, provides a number of suitable constitutions for cooperatives which wish to operate either under the auspices of the Registry of Friendly Societies or as a company limited by guarantee, under the Companies Act. They also publish a series of books and pamphlets concerning issues arising out of cooperative working.

Chapter Sixteen
5. Writing in *New Society*, in 1972. Reprinted in Paul Barker (ed), *Arts in Society* (Fontana).

Chapter Seventeen
6. The conference was organised by the London Association of Arts Centres, in conjunction with the Minority Arts Advisory Service, and was held at St Matthews Meeting Place in Brixton.
7. The point here is that 'revivals' in the world of mass-marketed popular culture represent the profitable recycling of old stock, which is presented as one more element in an eternal present, rather than a development of any sense of history. The fact that a particular piece of merchandise is being promoted for the second time is presented as its particular marketing hook, its gimmick, in the way that 'sex appeal' or fashionable drug use is presented as the marketing hook of other similar items of merchandise.

 This process, and its underlying economic factors, can be seen at work in the upsurge of interest which is often encouraged in an author's work at the point where it is passing into the public domain, and its publication or performance becomes cheaper and easier. The *Sherlock Holmes* stories of Sir Arthur Conan Doyle provide a recent example of this, as do the operettas of Gilbert and Sullivan.
8. A number of such machines are now available, manufactured principally by TEAC and Fostex. They record on standard, high quality cassettes, which they use at double the usual speed; and if used competently are capable of producing 'professional' quality recordings.

 It should be noted that open technological systems, suitable for an interactive and decentralised culture, are often to be found being marketed for domestic use, as Portastudios are. It is probably through a divergent use of domestic equipment that low cost, but effective open systems will be most easily developed.
9. The Social Arts Trust are based in Newcastle, and have engaged in a number of projects which are designed to develop towards a specific goal, reach it and then stop. A clear example of this process at work can be found in their booklet *Dunston Community Television*. The project described is centred around the year long struggle to set up a community television station designed from the outset to broadcast for one month only. At the end of the month a meeting was called, and those who attended were invited to take the issues raised further.

 The idea of the television station provided a focus for the ideas in the area, a means to carry them out, and a practical training in administration, bureaucratic wrangling, fund-raising and organising, in addition to the specific skills which flowed from actually running the station. At the end of the month everyone was

given the chance to use these skills to keep the station on the air, or to develop them further. They chose to tackle what they perceived as Dunston's underlying problem — the lack of jobs. Dunston Community Workshop was begun to research and organise employment within the local economy. Out of this grew the *Dunston Social Audit*, which produced a series of analyses showing how money flows in and out of Dunston.

Chapter Eighteen

10. Ken Worpole's essay, *Ideologically Laundered*, was published as part of *Friends and Allies* (Shelton Trust), the report which resulted from the community arts conference held in Salisbury in April 1983.

11. Currently local authority spending on the arts is legitimised by a variety of statutes which allow expenditure, while not compelling it. Section 132 of the 1948 Local Government Act, for example, says that authorities 'may do, or arrange for the doing of, or contribute towards the expenses of the doing of' almost any sort of entertainment. Even less specifically, but equally voluntarily, the Local Government (Financial Provisions) Act, 1963, permits local authorities to 'incur expenditure for any purpose which in their opinion is in the interests of their area or its inhabitants'. It is this clause from Section 6 of this Act which is now often used to justify both local authority action, and lack of action, since however much or little an authority does it can be deemed to be doing it 'in the interests of their area'.

Chapter Nineteen

12. I use the word *man-made* intentionally, since the creation of centralised monopolies has largely been the work of men, and a specific class of men at that. Their construction is related to, and is arguably a partial demonstration of, problems of patriarchy.

Other titles from Comedia

No. 23 **COMMUNITY, ART AND THE STATE** – storming the citadels
by Owen Kelly
paperback £3.95 hardback £10.50

No. 22 **READING BY NUMBERS** – contemporary publishing and popular fiction
by Ken Worpole
paperback £3.95 hardback £10.50

No. 21 **INTERNATIONAL IMAGE MARKETS** – in search of an alternative perspective
by Armand Mattelart, Michele Mattelart and Xavier Delcourt
paperback £4.95 hardback £12.00

No. 20 **SHUT UP AND LISTEN: Women and local radio – a view from the inside**
by Helen Baehr and Michele Ryan
paperback only £1.95

No. 19 **THE BRITISH MEDIA: a guide for 'O' and 'A' level students**
by Moyra Grant
paperback only £1.25

No. 18 **PRESS, RADIO AND TELEVISION** – An introduction to the media
edited by David Morley and Brian Whitaker
paperback only £1.50
published jointly with the Workers Educational Association

No. 17 **NINETEEN EIGHTY-FOUR IN 1984: Autonomy, Control and Communication**
edited by Crispin Aubrey and Paul Chilton
paperback £3.95 hardback £10.50

No. 16 **TELEVISION 'TERRORISM': Political violence in popular culture**
by Philip Schlesinger, Graham Murdock and Philip Elliott
paperback £4.95 hardback £12.00

No. 15 **CAPITAL: Local Radio and Private Profit**
by Local Radio Workshop
Paperback £3.95 hardback £10.50

No. 14 **NOTHING LOCAL ABOUT IT: London's local radio**
by Local Radio Workshop
paperback £3.95 hardback £10.50

No. 13 **MICROCHIPS WITH EVERYTHING: The consequences of information technology**
edited by Paul Sieghart
paperback £3.50 hardback £9.50
Published jointly with the Institute of Contemporary Arts

No. 12 **THE WORLD WIRED UP – Unscrambling the new communications puzzle**
by Brian Murphy
paperback £3.50 hardback £9.50

No. 11 **WHAT'S THIS CHANNEL FO(U)R? An alternative report**
edited by Simon Blanchard and David Morley
paperback £3.50 hardback £9.50

No. 10 **IT AIN'T HALF RACIST, MUM – Fighting racism in the media**
edited by Phil Cohen
paperback £2.50 hardback £7.50
Published jointly with the Campaign Against Racism in the Media.

No. 9 **NUKESPEAK – The media and the bomb**
edited by Crispin Aubrey
paperback £2.50 hardback £7.50

No. 8 **NOT THE BBC/IBA – The case for community radio**
by Simon Partridge
paperback £1.95 hardback £5.00

No. 7 **CHANGING THE WORD: The printing industry in transition**
by Alan Marshall
paperback £3.50 hardback £9.50

No. 6 **THE REPUBLIC OF LETTERS – Working class writing and local publishing**
edited by David Morley and Ken Worpole
paperback £2.95 hardback £8.50

No. 5 **NEWS LTD – Why you can't read all about it**
by Brian Wheeler
paperback £3.25 hardback £9.50

No. 4 **ROLLING OUR OWN – Women as printers, publishers and distributors**
by Eileen Cadman, Gail Chester, Agnes Pivot
paperback £2.25 hardback £7.50

No. 3 **THE OTHER SECRET SERVICE – Press distribution and press censorship**
by Liz Cooper, Charles Landry, Dave Berry
paperback only £0.80

No. 2 **WHERE IS THE OTHER NEWS – The news trade and the radical press**
by Dave Berry, Liz Cooper, Charles Landry
paperback £1.75 hardback £4.50

No. 1 **HERE IS THE OTHER NEWS – Challenges to the local commercial press**
by Crispin Aubrey, Charles Landry, David Morley
paperback £1.75 hardback £3.50